MORTOSIN

Datchet Library Montagu House 8 Horton Road Datchet SL3 9ER Tel: 01753 545310

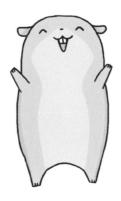

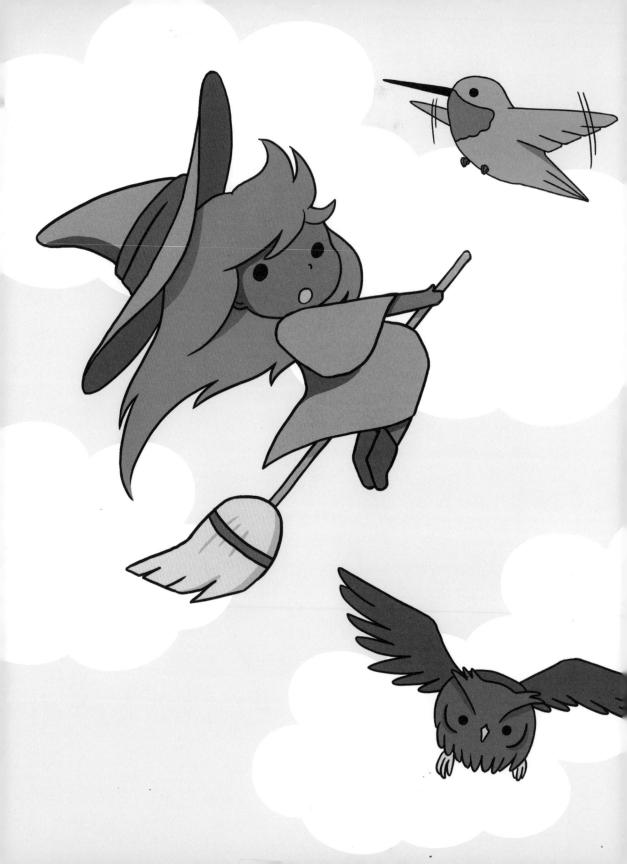

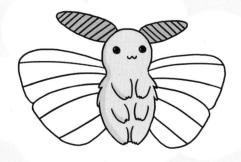

Angela Nguyen

A QUARTO BOOK

First published in 2017 by Search Press Ltd Wellwood North Farm Road Kent TN2 3DR

Copyright @ 2017 Quarto Publishing plc

All rights reserved. No part of this publication may be reproduced, stored in a retrieval system or transmitted in any form or by any means, electronic, mechanical, photocopying, recording or otherwise, without the permission of the copyright owner.

ISBN: 978-1-78221-575-2

10 9 8 7 6 5 4 3 2 1

Conceived, designed, and produced by Quarto Publishing plo 6 Blundell Street London N7 98H

www.quartoknows.com

QUAR.DCUT

Editor: Kate Burkett
Senior art editor: Emma Clayton
Designer: Karin Skanberg
Art director: Caroline Guest
Creative director: Moira Clinch
Publisher: Samantha Warrington

Manufactured in China by Toppan Leefung

Angela's World

1

CHAPTER 1

GETTING STARTED

Tools & surfaces
Techniques for cuties

CHAPTER 2

CUTE PEOPLE			16
People	18	Astronaut	34
Poses	20	Chef	36
Expressions	22	Cowboy	38
Tops	24	Cowgirl	39
Bottoms	26	Doctor & Nurse	40
Hats	28	Farmer	41
Glasses & Bags	29	Ninja	42
Jewellery	30	Sailor	44
Shoes	31	Witch	46
Police	37		

CHAPTER 3

CUTE CREATURES

Dog 50 Lion Cat 52 Tiger

Rabbit

Elephant

Hamster

Squirrel

Bear

Deer

[ny

Pig

Turtle

Koala

Monkey

Raccoon

53 Giraffe

54

60

61

62

63

64

65

Owl

Rat

Dolphin

Shark

Alligator & Crocodile Colourful birds

City birds

Ducks

flightless birds

Hunting birds

Colourful fish

57 58 59

56

70 77

73

74

75

76

77

78

80

81

66

67

68

69 Caterpillar Butterfly & Moth Grasshopper

Ree

Stingray

Tentacles

Whale

Ladybird

Other insects

91 Dragon

92 94 Unicorn & Pegasus 95

48

82

83

84

86

87

88

89

90

Phoenix 96 Loch Ness monster Werewolf 97

CHAPTER 4

100

107

103

104

105

106

108

110

112

114 115

116

Sushi

Flowers

Trees

	Buildings
	Skyscraper
	Tent
	Chairs
)	Tables
	Cooking tools
	Vehicles

Air vehicles Water vehicles Bowl Bread

Candyfloss

Pizza

Burger Sweets Dessert **fruit**

120 122 123 124

117

118

119

125 Hanging plants 126 Credits 128

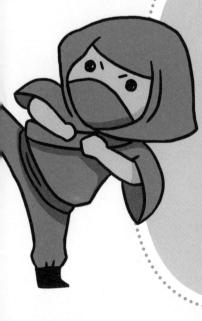

I'm an artist who specialises in drawing cute stuff. Anything small, fluffy or with a face, you can count on me! For as long as I can remember, I've always had the urge to draw cute things. An empty whiteboard is a calling to draw something, anything! An open sketchbook is an opportunity to sneak a cute note to the owner!

One of the reasons I like to draw is the mysterious phenomenon that cute illustrations always make people happy. Even if it is just a small doodle on someone's napkin, it never ceases to brighten a person's day. It also can't be helped when cute things are all around us. We find them in animals, like dogs, and places, such as our own homes. We find them in the activities we enjoy and the people we love.

In this book, I've illustrated a collection of cute people, animals and objects that are a big part of my life. Whether you're a beginner or the best artist in your group of friends, why not join me and learn how to draw

cute stuff, too?

Angela Nguyen

Arfine

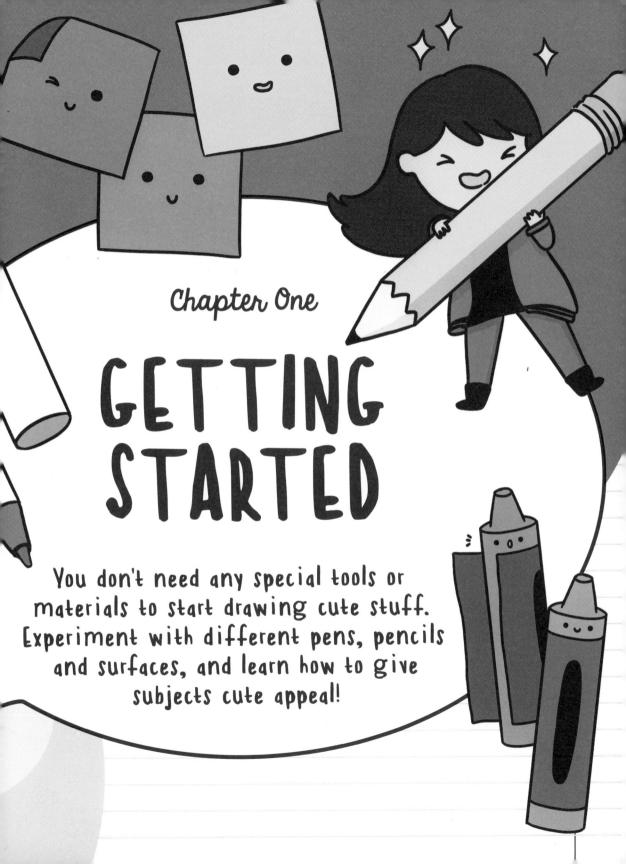

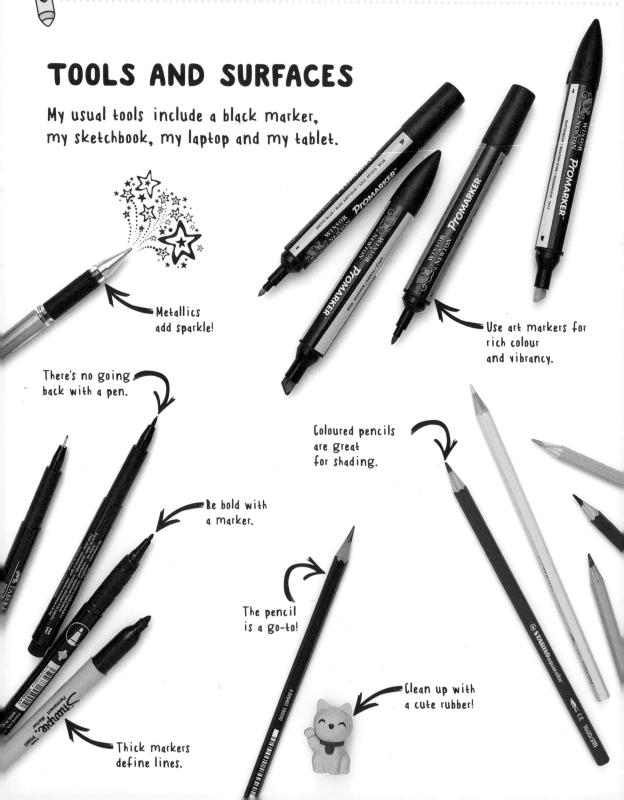

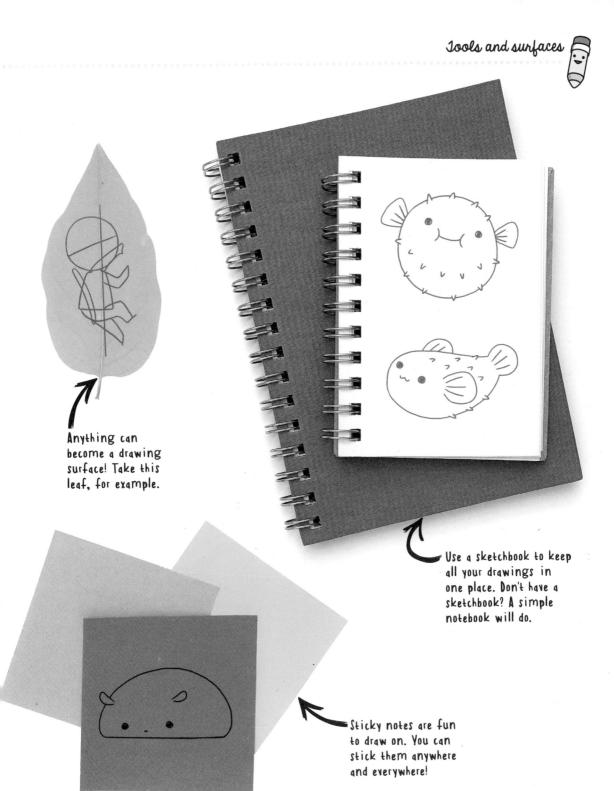

TECHNIQUES FOR CUTIES

Anyone can draw cute things with these simple guidelines.

1 Let's begin by drawing some basic shapes; a circle, triangle and square. Nothing cute about them; they are just a lot of shapes.

3 Give your rounded shapes a face. Now your simple shapes have been transformed into cute shapes! All you need for cuteness is roundness and faces.

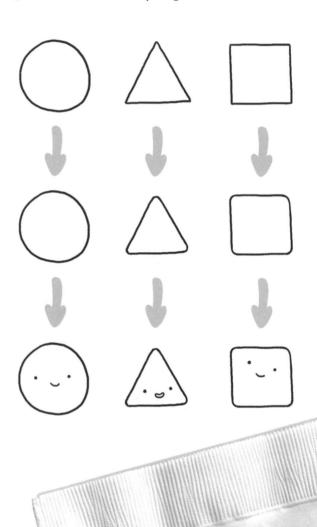

Cute eyes can be achieved with a simple dot or line. You can scribble in the dots to give a 'sparkle' effect.

NOSE AND MOUTH

Add a small nose for a punch of cuteness. Draw a round mouth and perhaps a cheeky tongue!

COLOURS

Pastel colours are always cute. Try to find light colours for extra cuteness!

SHADOWS

Shadows give your drawings dimension. Consider where your light is coming from. Areas near the light source are paler and those further away are darker.

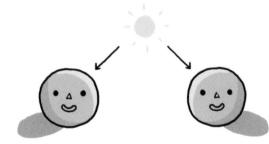

EFFECTS

Sparkles, flowers, hearts and blushing always make your drawings cuter.

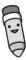

HOW TO MAKE EVERYTHING CUTE

The main four things to remember when drawing cute things are: 1 Simplify, 2 light colours, 3 roundness and 4 faces.

Simplify and use less detail.

This way, the drawing can focus on being cute! Focus on simple shapes and take out the details to make cute drawings.

2 Light colours complement simple drawings.

I prefer to use pastel colours rather than bright, intense ones.

3 Roundness helps to soften drawings.

Taking away sharp features and adding roundness to your drawings makes them cuter. There's just something about that small and chubby look...

Adding a cute face is the ultimate secret!

Transform anything you want into something cute by drawing on a face.

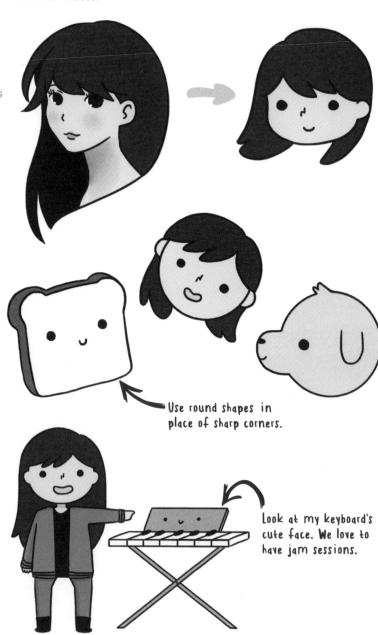

PROPS MAKE PERSONALITIES

Props can give your characters more personality. People can have items like clothing or jewellery. Even animals can have accessories.

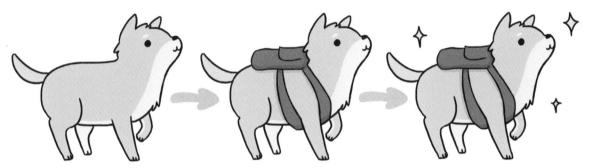

- This is just a simple dog. But added extras transform it.
- Add a backpack and now it is an adventurous dog!
- 3 Add sparkles and now it is a fabulous dog!

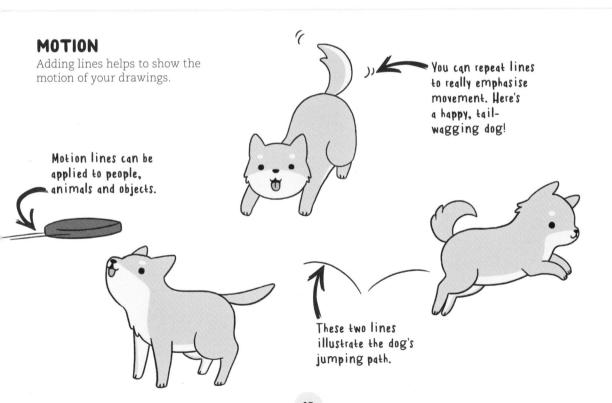

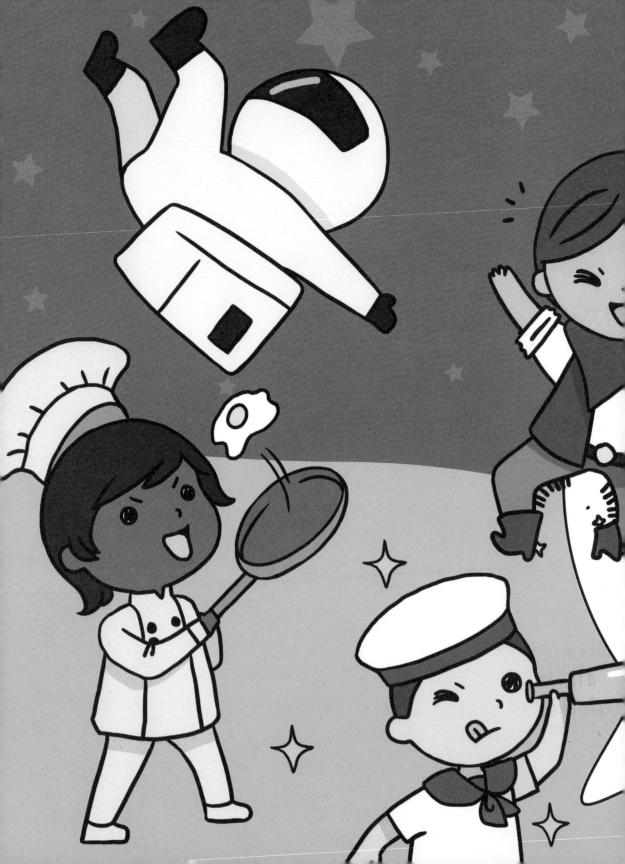

PROPORTIONS

Two-and-a-half circles make a basic figure.

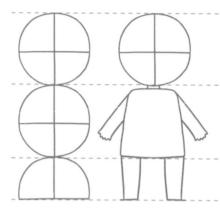

PERSPECTIVE

I like to use horizontal and vertical lines to help me draw people turned in different directions. The horizontal line is where the eyes and nose rest. The vertical line is the centre of the person's face.

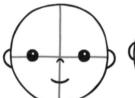

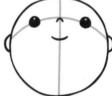

If you draw the horizontal line higher, your person will be looking up.

Move the horizontal line lower and your person will be looking down.

HAIRSTYLES

There are so many different hairstyles you can give your character. Have a look on the Internet, or at your friends and family, for more inspiration.

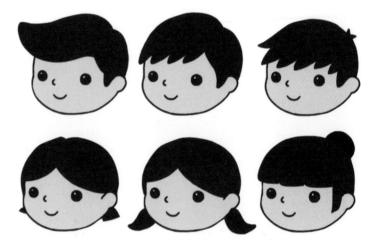

Put some clothes on and then you've got a person.

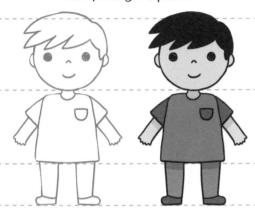

You can add eyelashes to make your person more feminine.

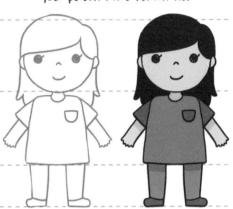

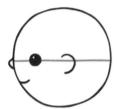

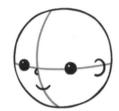

If you draw the
vertical line to the
left, your person will
be looking left.

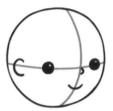

Move the vertical line to the right and your person will be looking right.

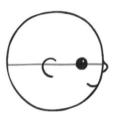

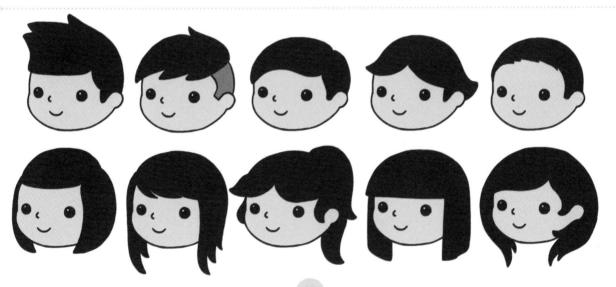

POSES

Try some of these poses!

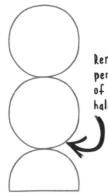

Remember: a person is made of two-and-ahalf circles.

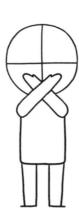

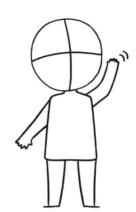

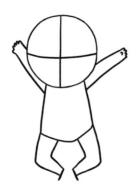

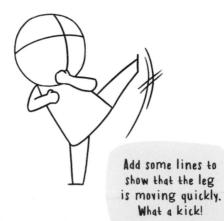

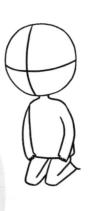

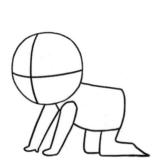

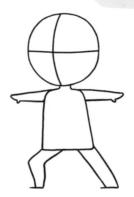

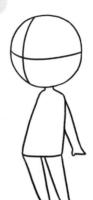

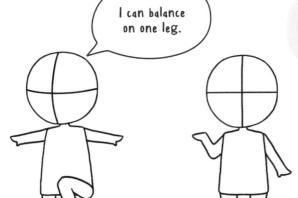

Raise the horizontal guideline on your character's face to make him or her look up.

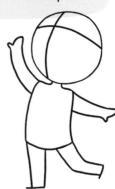

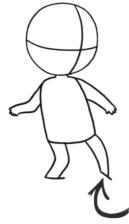

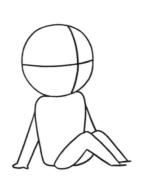

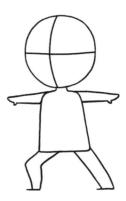

Changing the angle of the feet can help with the gesture. Try making your person tiptoe.

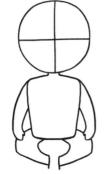

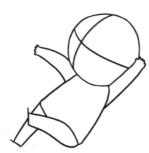

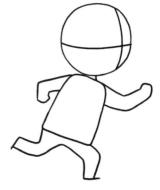

EXPRESSIONS

What mood is your character in?

HAPPY

I call these 'smiling eyes'.

ANNOYED

CONFUSED

WORRIED

Draw some lines on the side of the face to add to the expression.

DISGUSTED

EXCITED

One of my favourite symbols is sparkles.

SAD

Eyebrows can help emphasise an expression.

ANGRY

The eyebrows are so expressive!

SCARED

Add chills around the face for a more spooky effect.

FULL

Add eye bags to exaggerate the eyes.

EMBARRASSED

Add some blush.

GUILTY

LOVE

You can always change the shape of your person's eyes.

SMIRK

Jagged lines and an open jaw are key to this expression.

SHOCK

Symbols like a water drop can make your person look guiltier.

CRYING

Watery eyes and a watery waterfall.

TIRED

A cloud coming out of the mouth looks like a big sigh.

Now that you know the basics of drawing a person, you can dress them up in different ways.

A T-shirt is a simple top. You can add a little pocket to spice things up.

A strapless dress is easy to draw; just remove the sleeves!

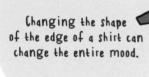

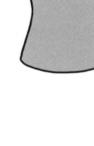

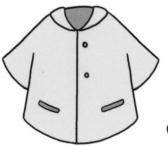

A belt can be a nice touch to a dress.

Keep your character warm by giving them a long-sleeved jumper.

If you draw a T-shirt and cut off the sleeves, you get a cut-off shirt.

Combine and layer tops to create sets.

By changing the collar of a T-shirt, you can get different kinds of shirts, like this V-neck.

Add a cute cat graphic, too.

BOTTOMS

There are so many different styles of bottoms you can draw to dress your character. Here are just a few to choose from.

Anything can go with jeans.

Sweatpants are baggy and have soft edges.

These are even baggier!

There are so many patterns that can be applied to clothing.

Try this polka-dot print.

Draw jagged patches for ripped trousers.

Adding an extra fold can transform your skirt.

Making clothing wider and rounder will emphasise its puffiness.

Don't be afraid to try asymmetry, too!

Draw a matching top to complete your pyjamas.

You can explore different kinds of trousers just by changing the edges.

I love drawing plant graphics.

Overalls can wrap over your top.

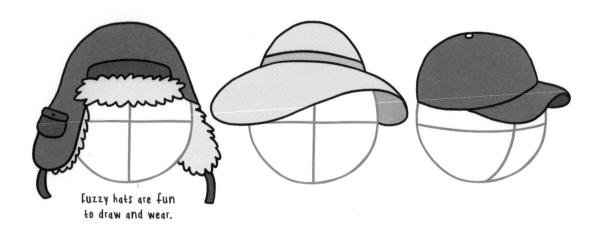

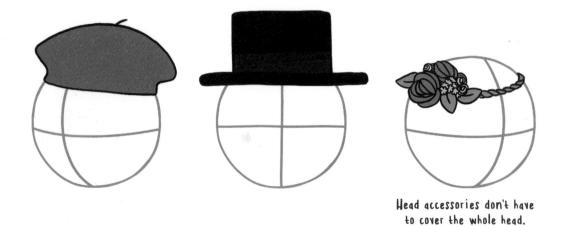

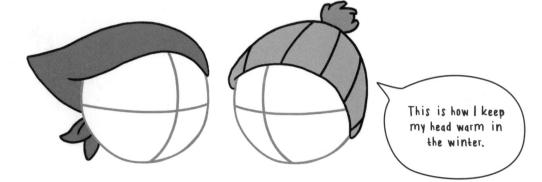

GLASSES

You can change the size of your glasses to be small or big.

The horizontal guidelines on your character's face are super helpful for drawing glasses.

Don't forget that you can change the shape, too.

BAGS

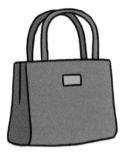

A tote bag can be held or placed over one shoulder.

> A messenger bag is drawn across the body, like the side bag.

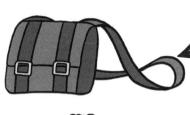

Strings for straps? Must be a drawstring.

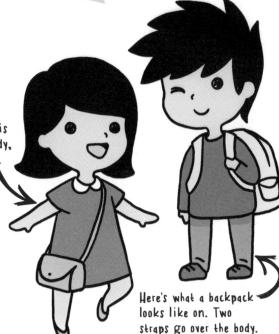

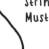

JEWELLERY

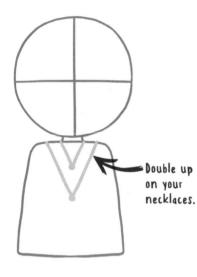

A small necklace around the neck can make a nice accessory.

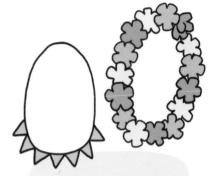

Drawing the same shapes over and over can create a necklace pattern, like this flower lei and triangle necklace.

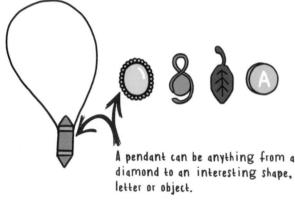

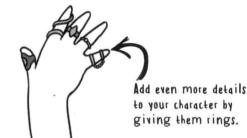

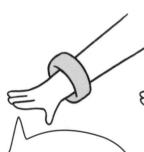

Sometimes I'll play with the size of my bracelets.

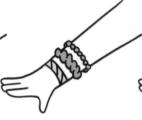

Add as many bracelets to your character as you would like.

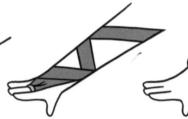

Intricate sleeves are always interesting.

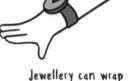

Jewellery can wrap around the arm, too.

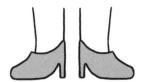

The key to drawing high heels is to angle your feet.

Boots rise higher on the legs than trainers.

Even complicated shoes with multiple straps can be easily drawn over your sketch.

Bunny shoes can have faces, too.

Shoes can be drawn on top of your character's feet.
These trainers fit perfectly over the sketch.

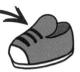

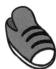

POLICE

Match outfits and add accessories to complete your character!

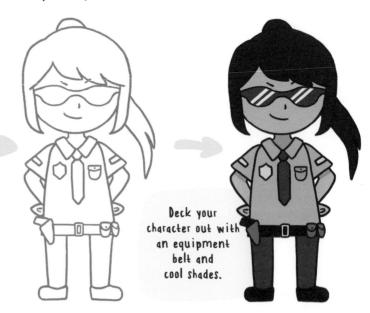

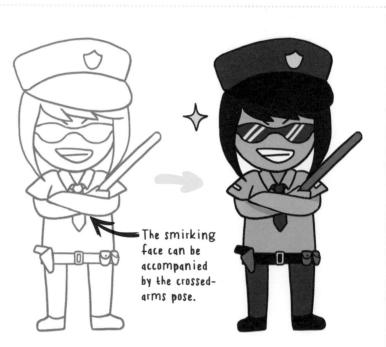

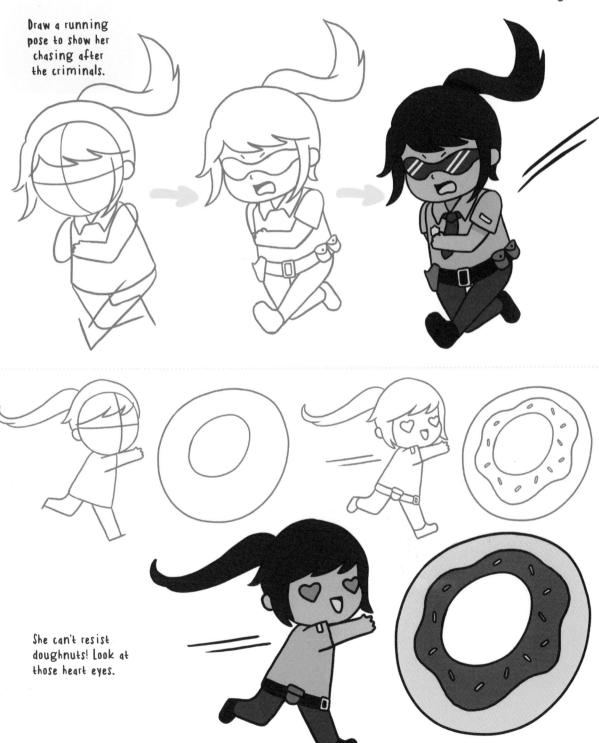

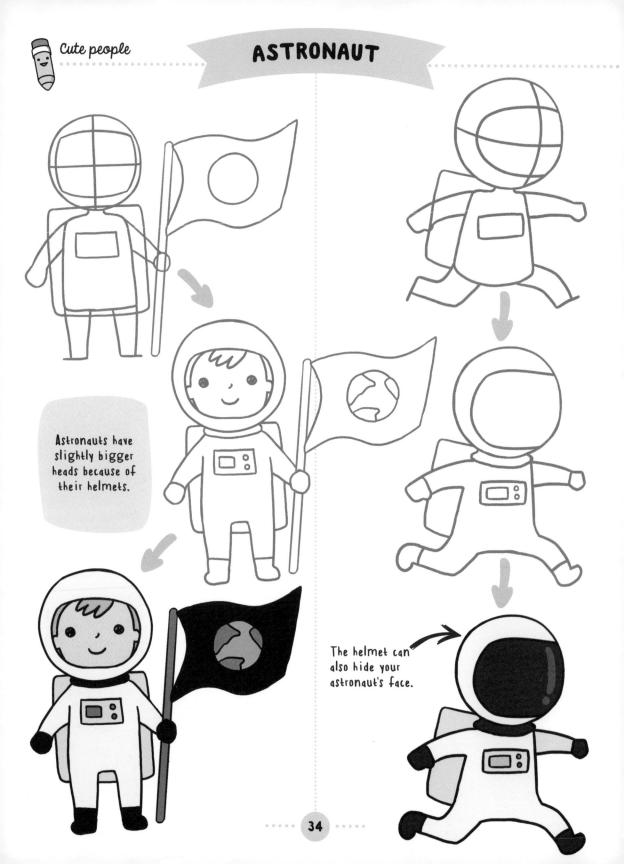

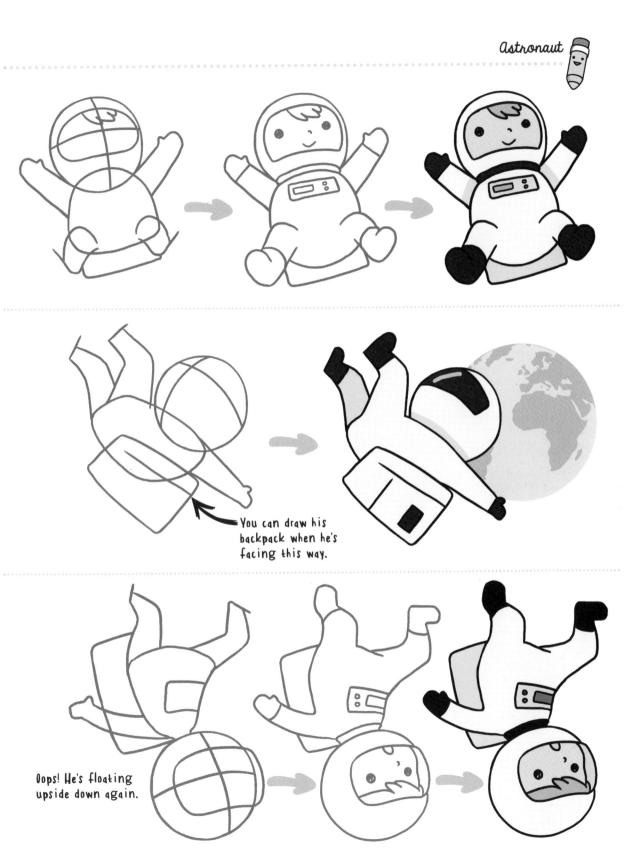

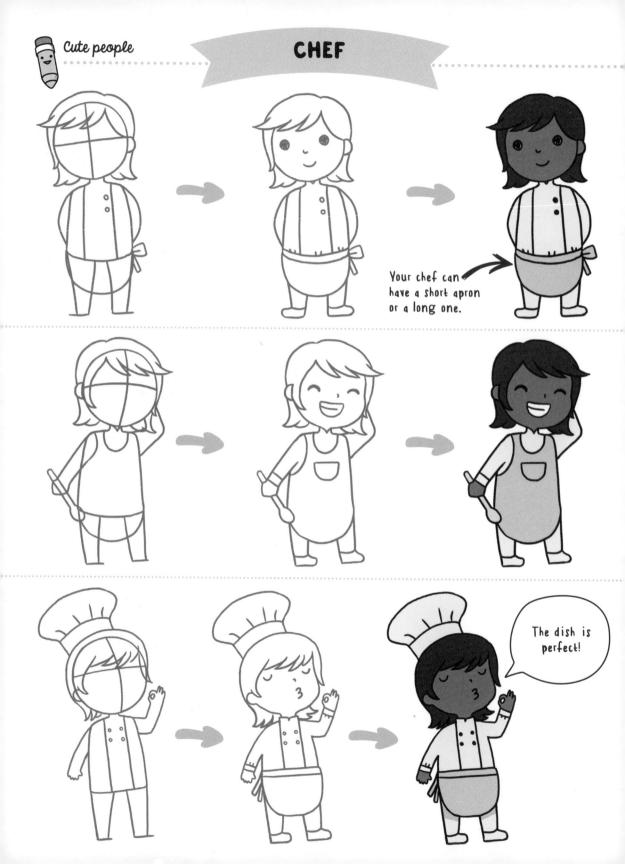

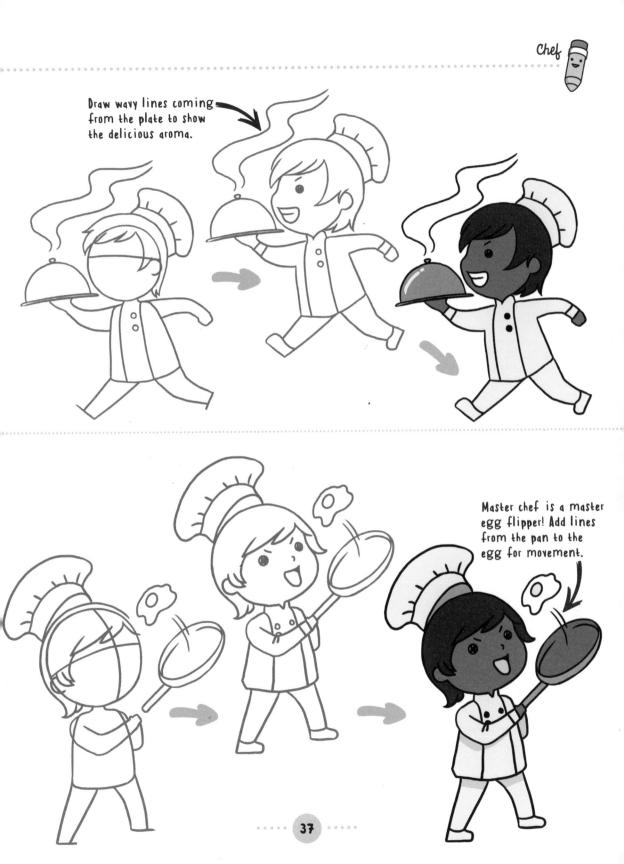

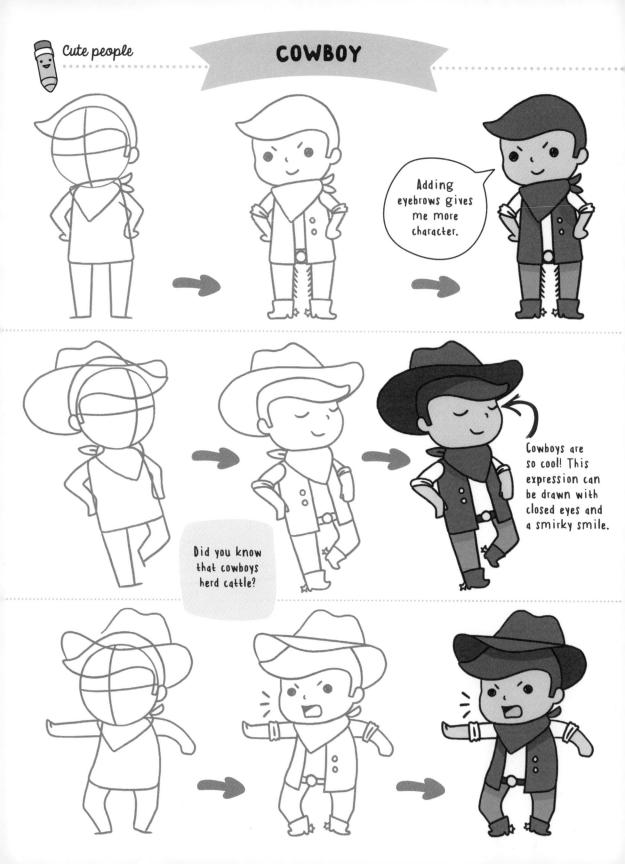

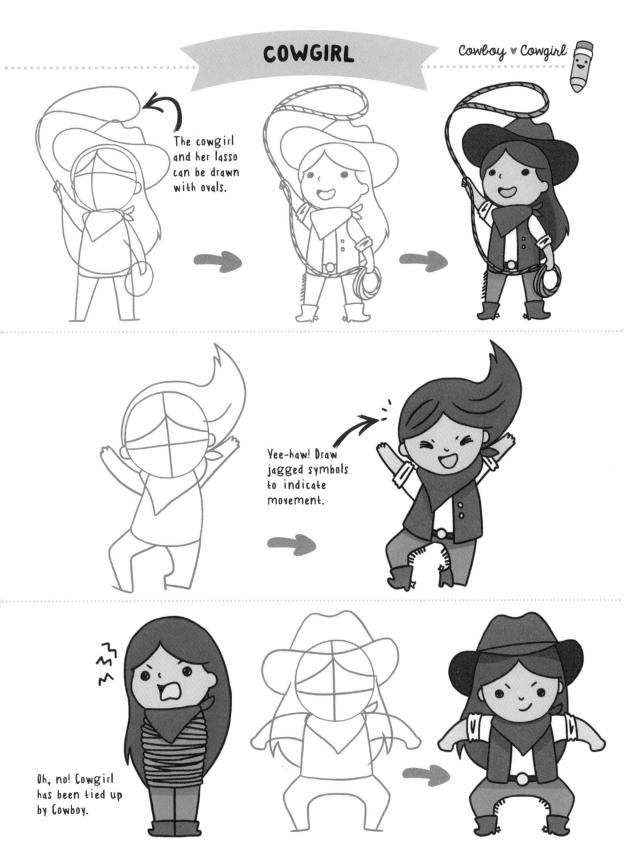

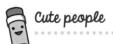

DOCTOR & NURSE

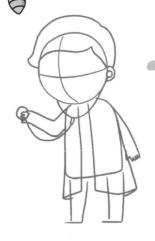

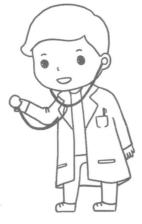

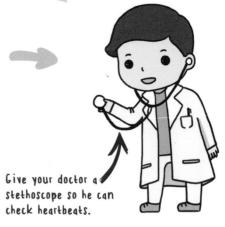

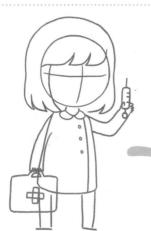

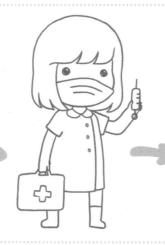

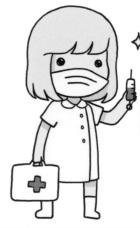

Ouch! Sharp! Nurses have to be careful with their gear.

This coat has a lot of pockets to hold notes and pens.

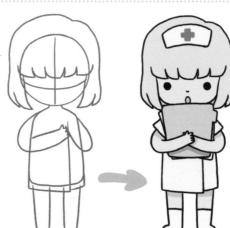

Add symbols near the face for a surprised effect.

FARMER

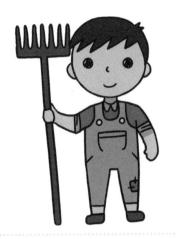

Yum! Add a bite mark to the apple the farmer is eating.

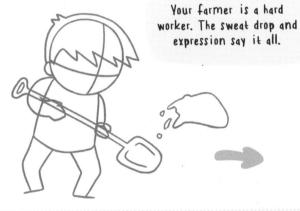

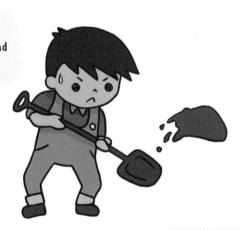

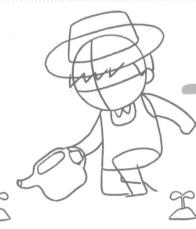

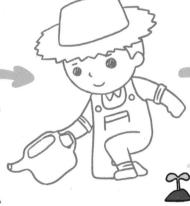

NINJA

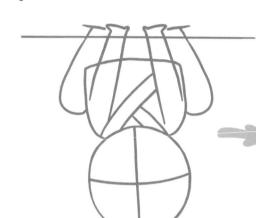

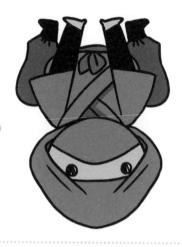

Draw your ninja right-side up and then turn your paper upside down.

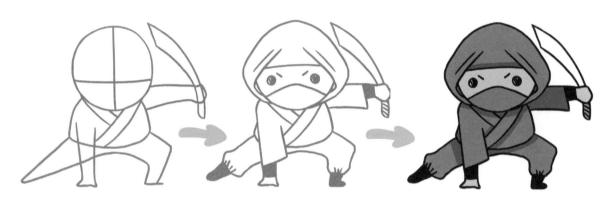

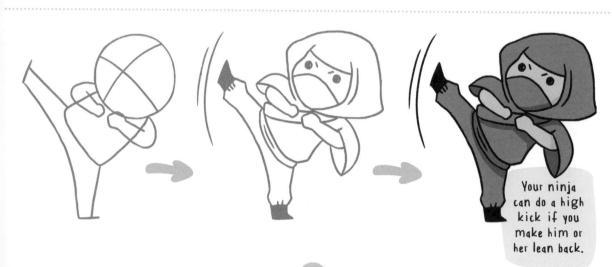

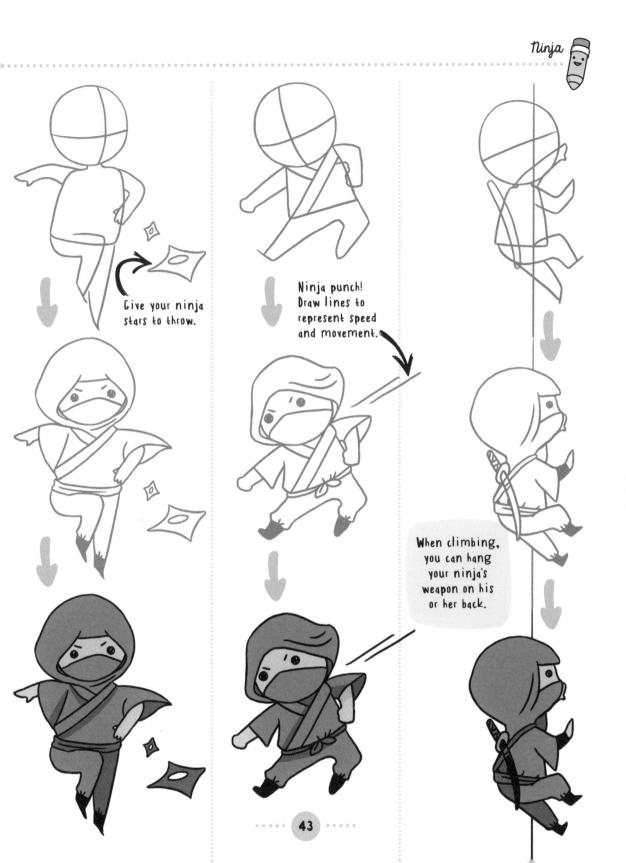

SAILOR

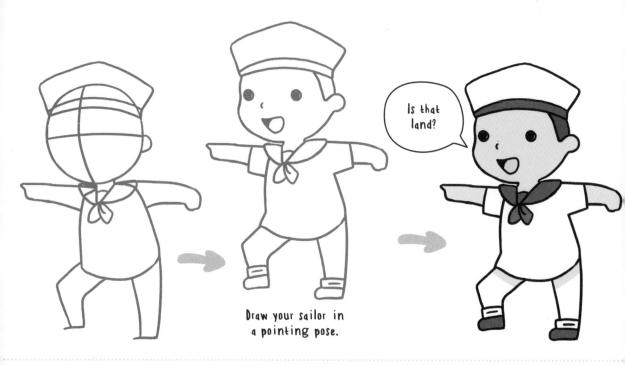

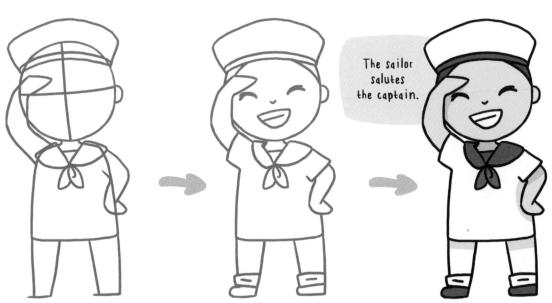

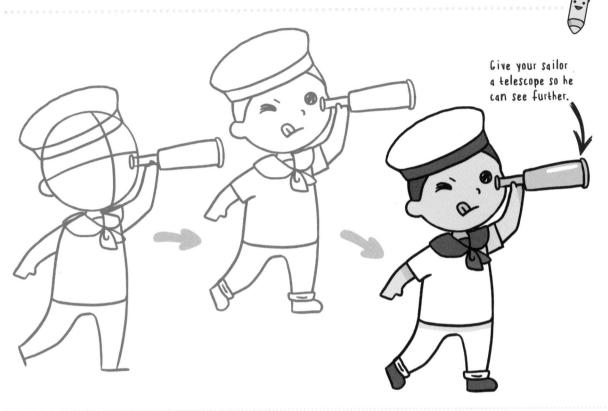

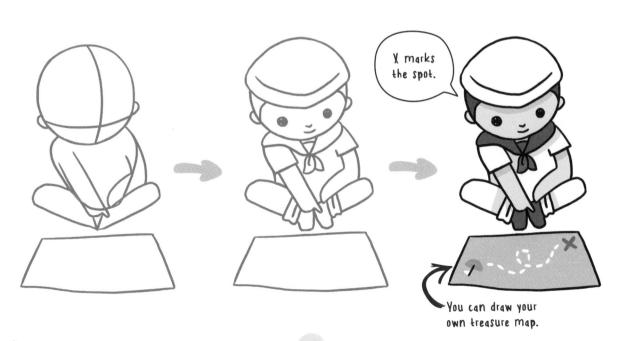

WITCH

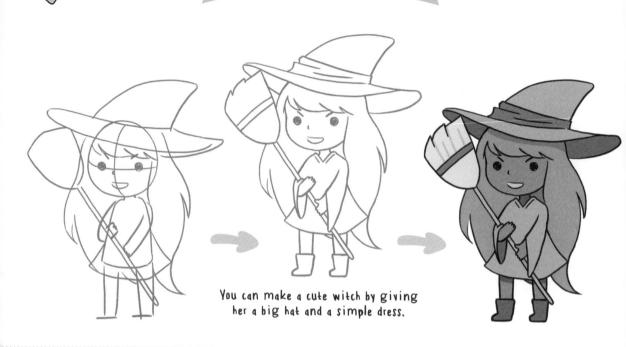

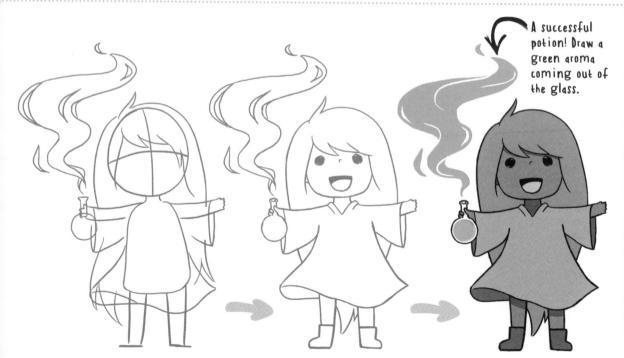

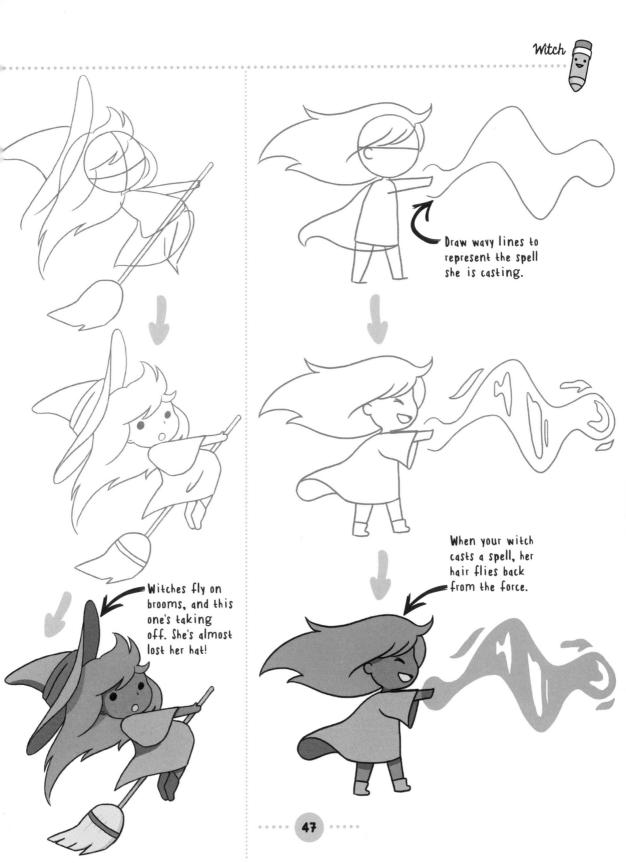

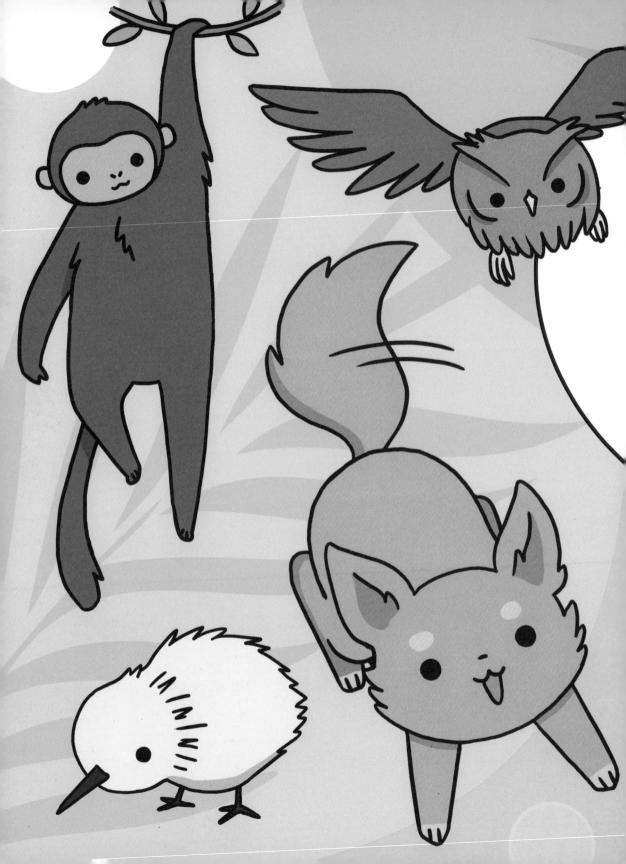

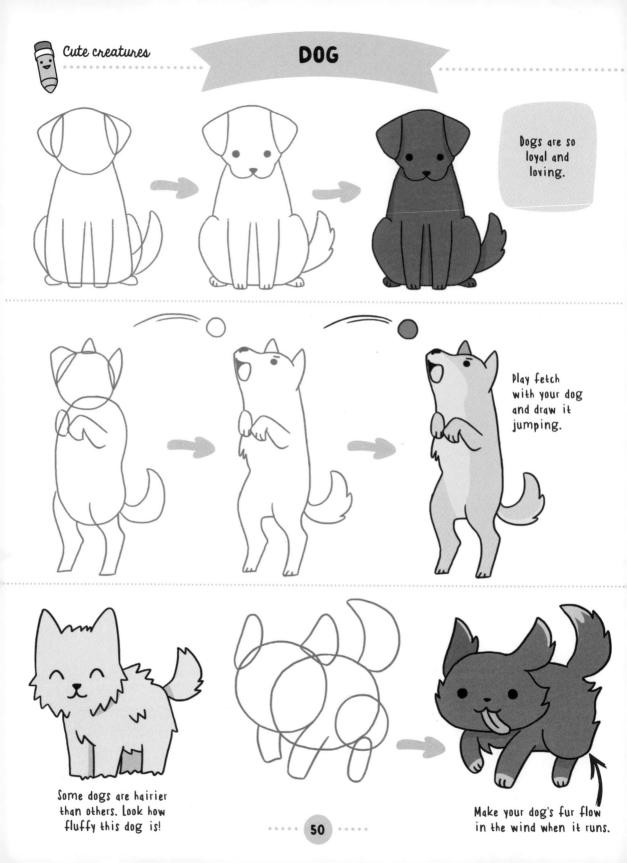

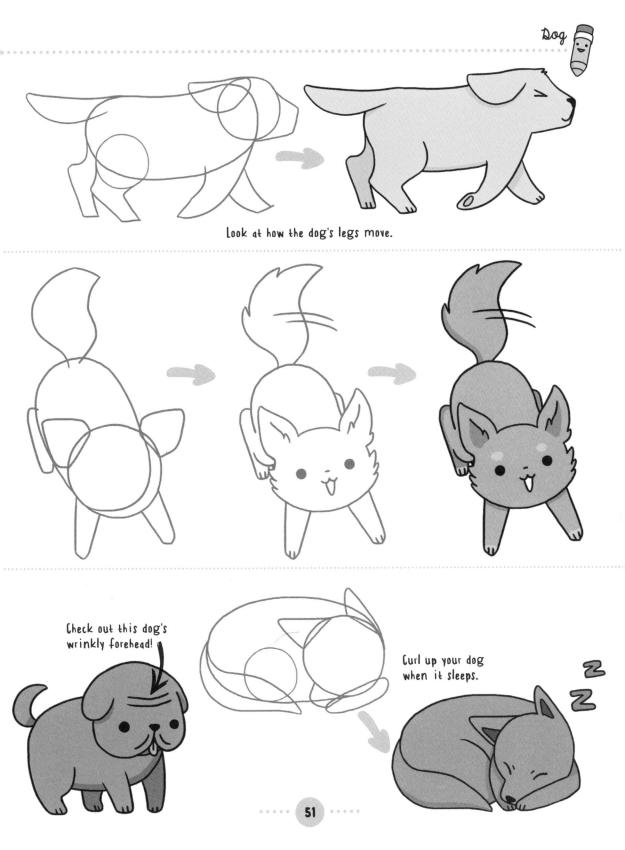

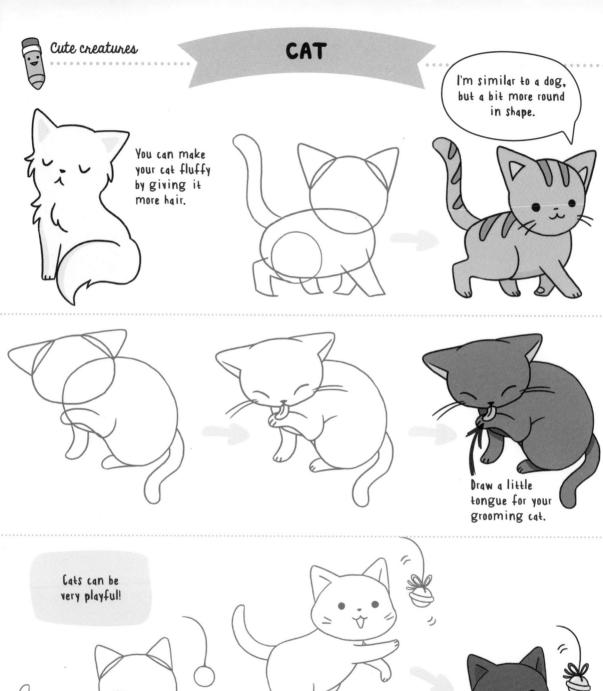

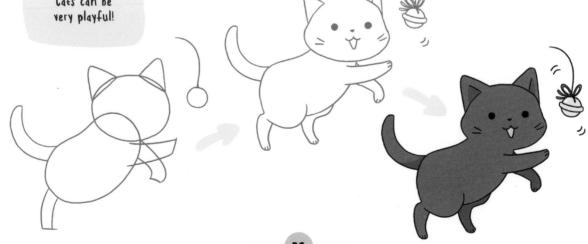

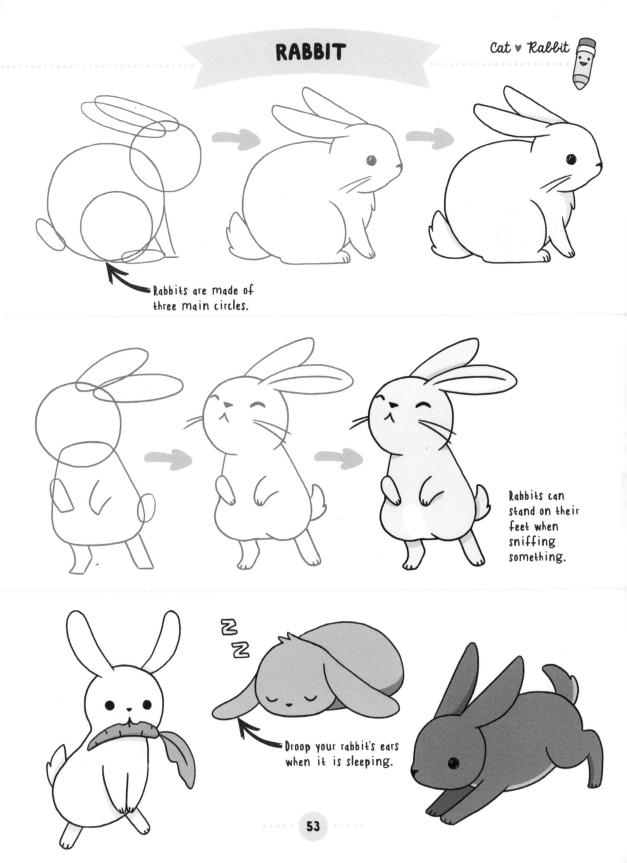

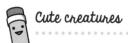

ELEPHANT

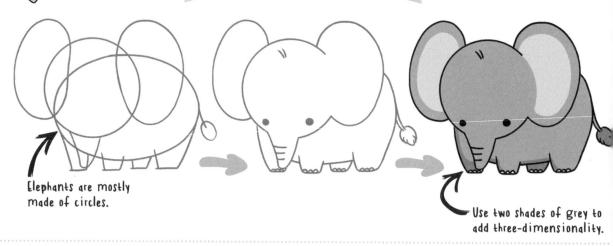

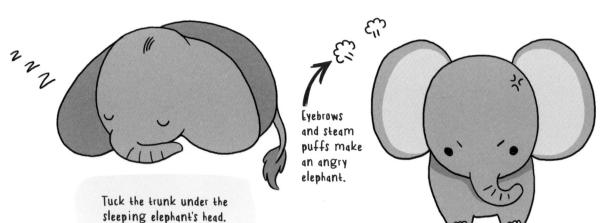

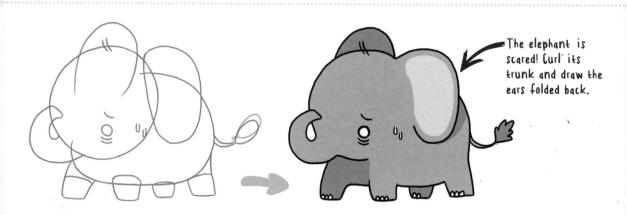

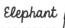

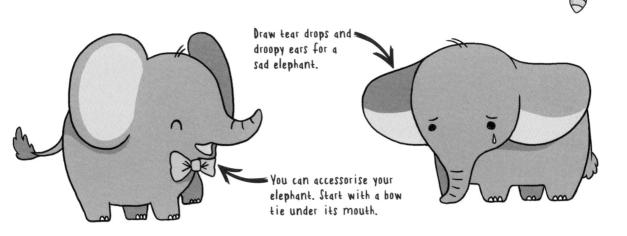

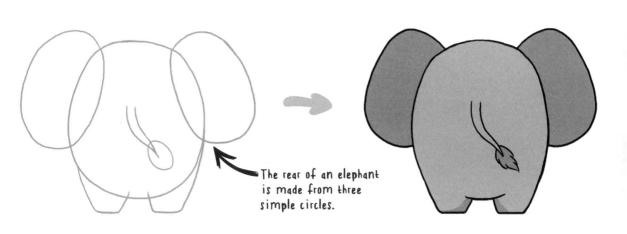

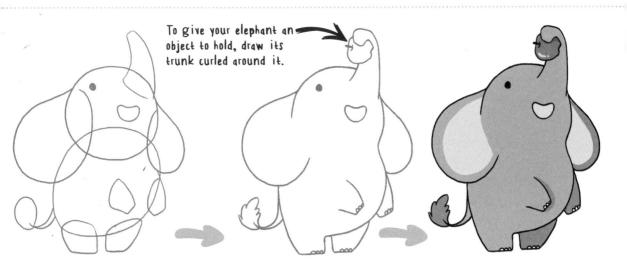

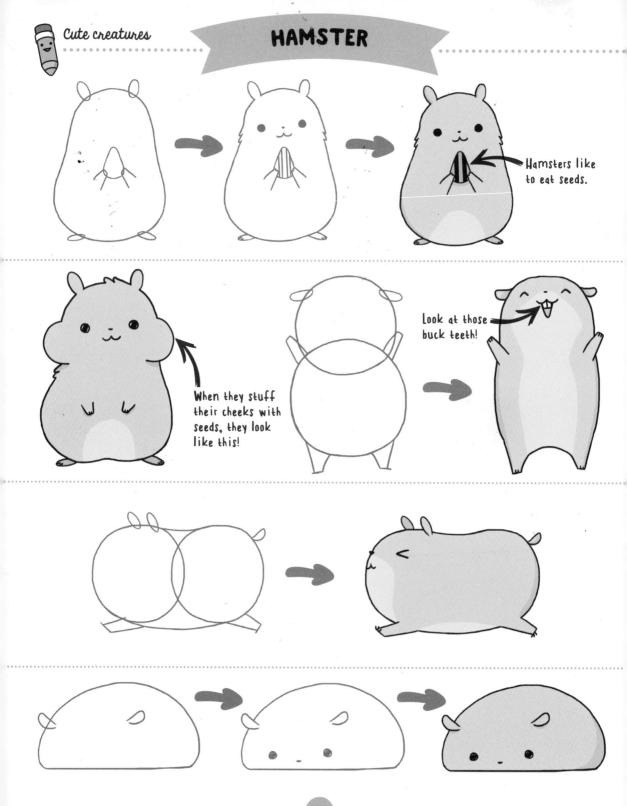

SQUIRREL

Hamster ♥ Squirrel

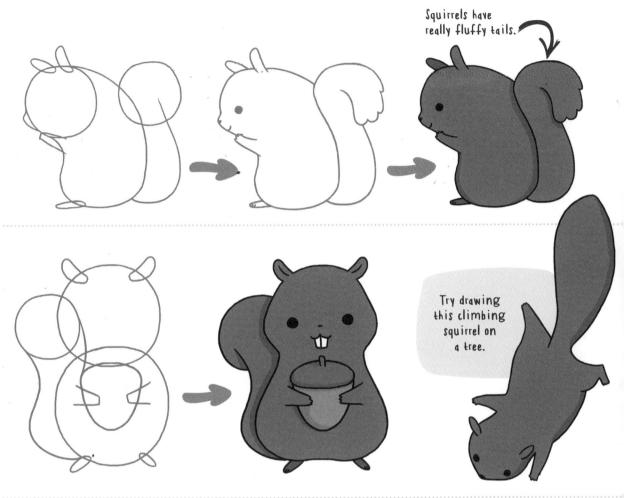

Drawing a chipmunk is similar to a squirrel, but make the tail less fluffy.

BEAR

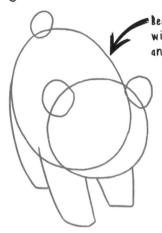

Bears are drawn with big circles and paws.

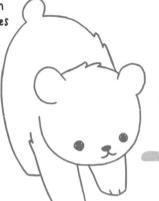

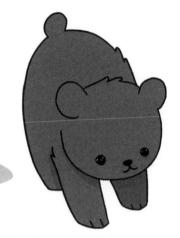

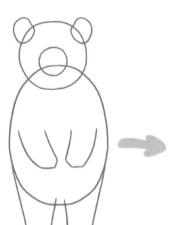

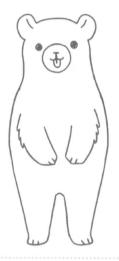

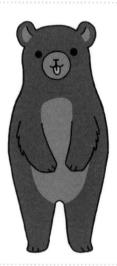

Bears get really big when they stand!

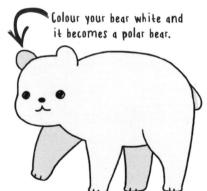

Pandas have black arms, legs, ears and eyes.

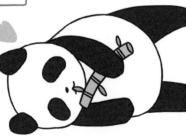

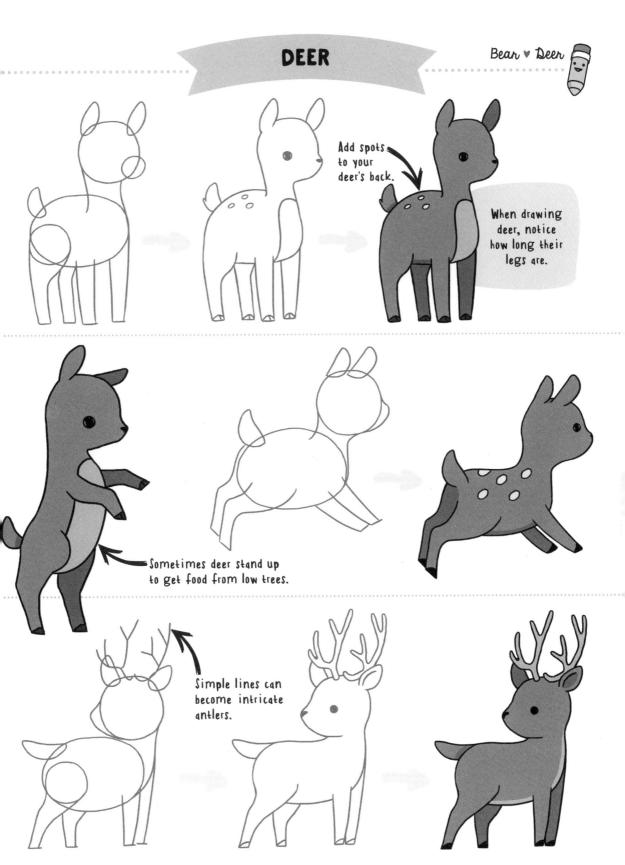

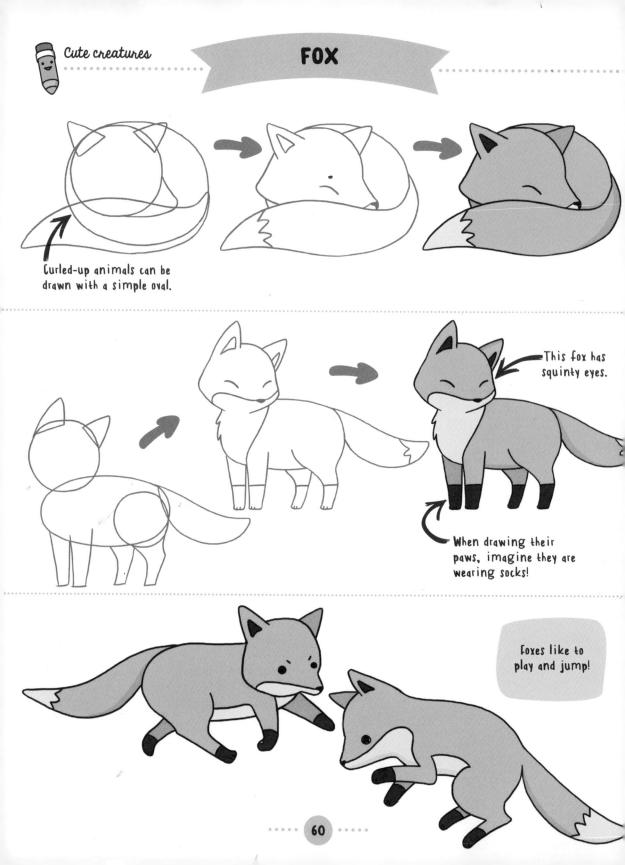

RACCOON

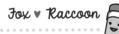

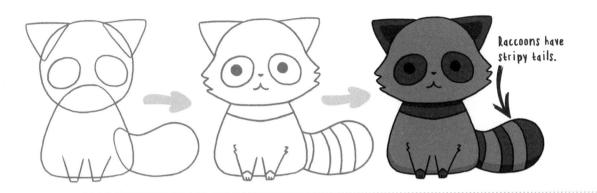

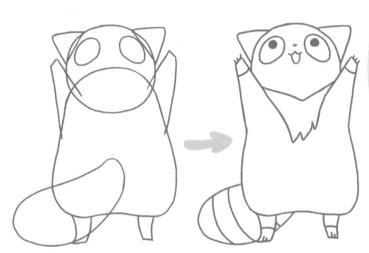

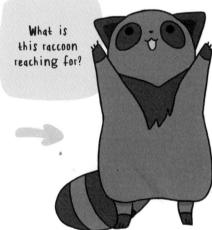

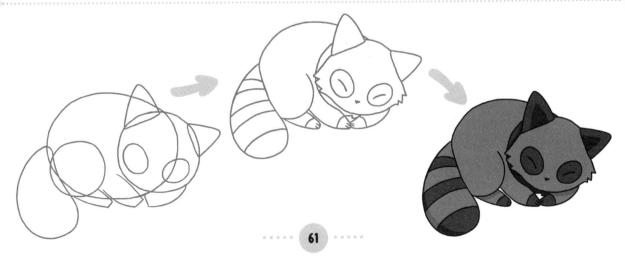

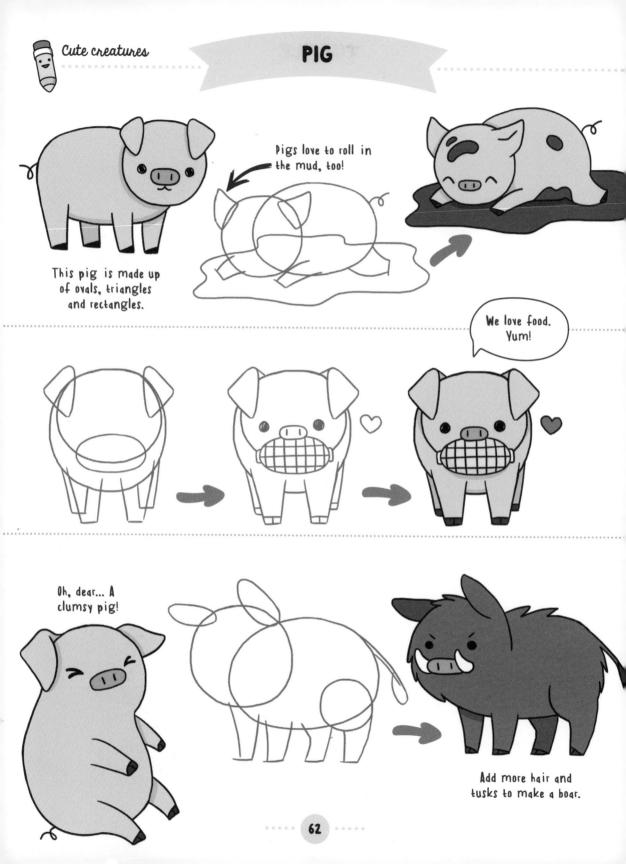

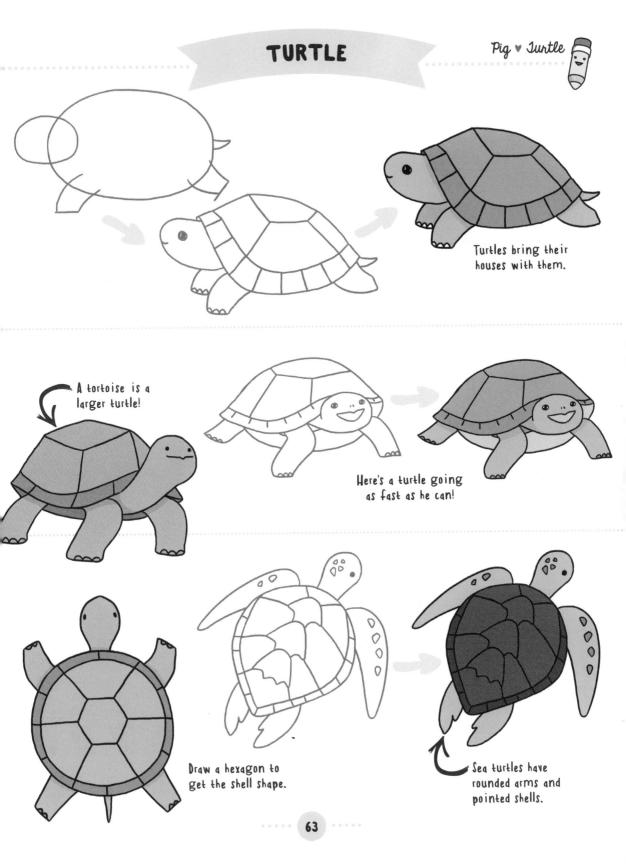

KOALA

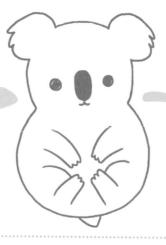

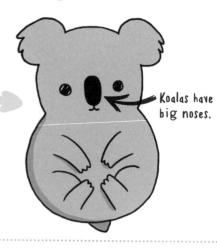

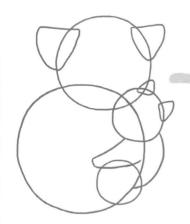

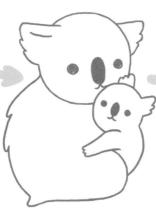

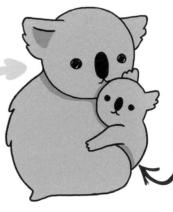

Aww, look at the baby koala.

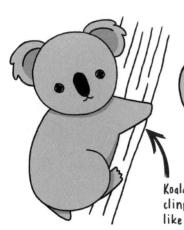

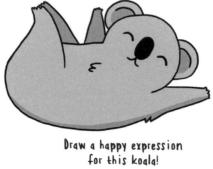

Koalas like to cling to things, like trees.

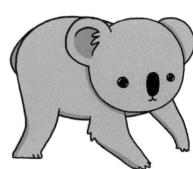

Koalas always seem to be laying around, but don't forget they crawl, too.

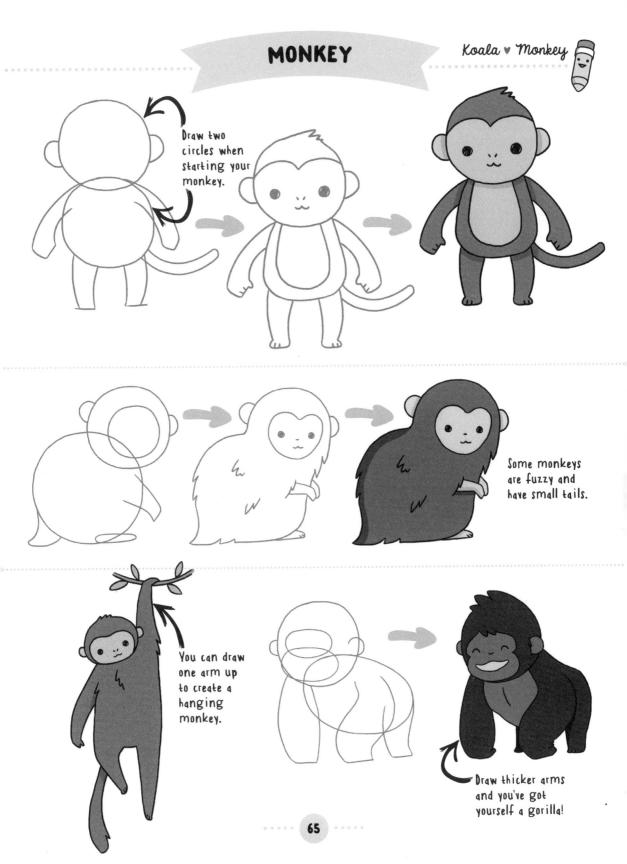

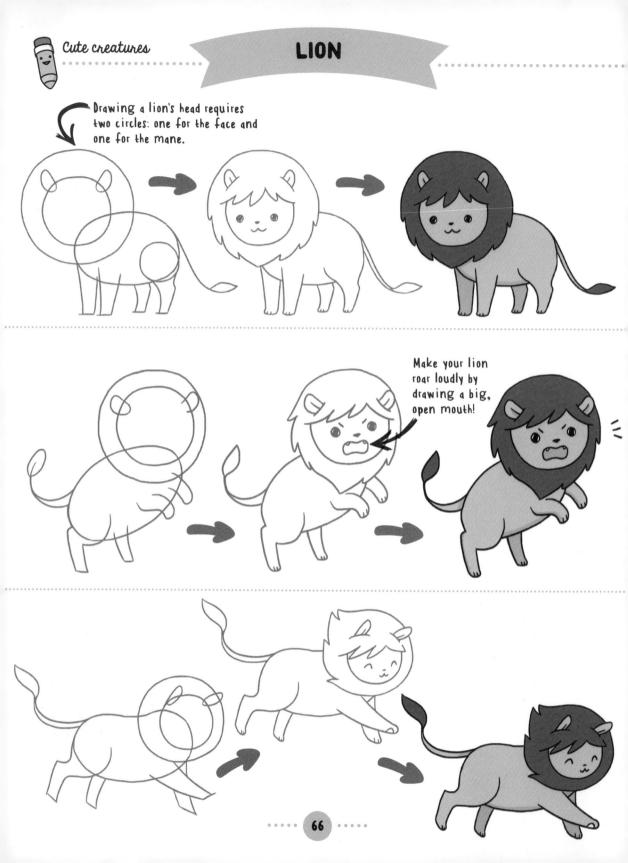

TIGER

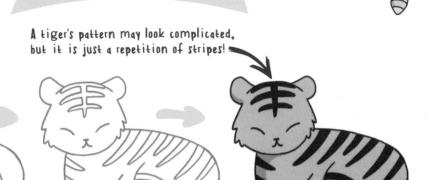

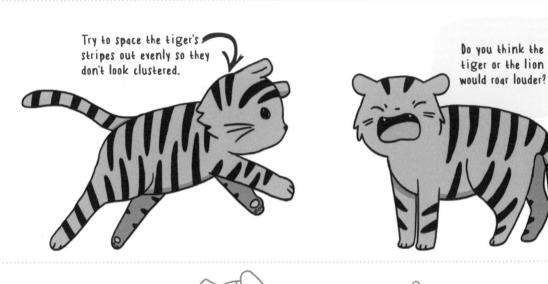

Tuck the front paws in between the legs when the tiger is running.

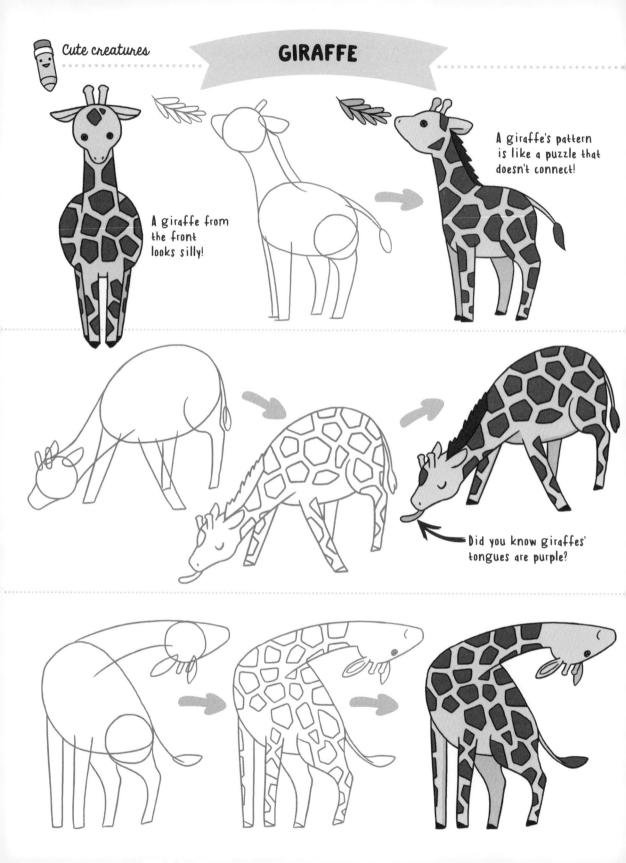

ALLIGATOR & CROCODILE

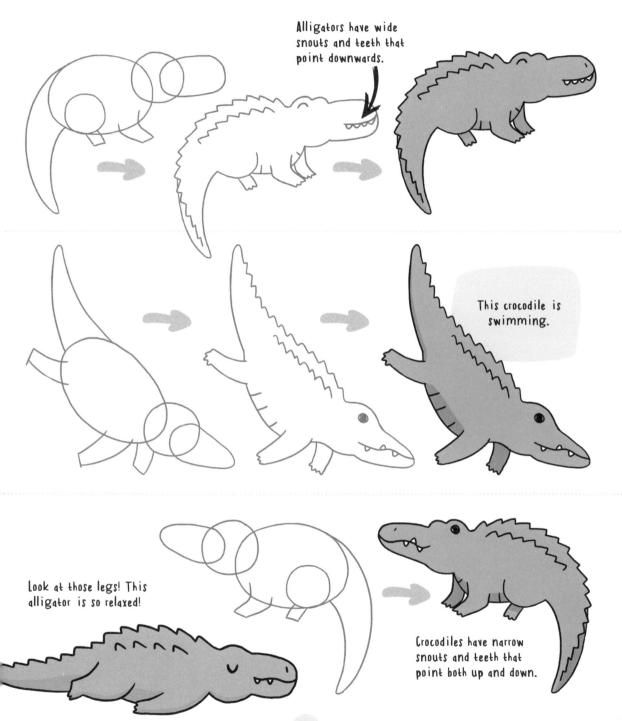

COLOURFUL BIRDS

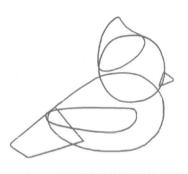

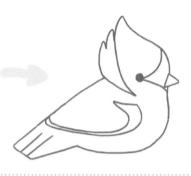

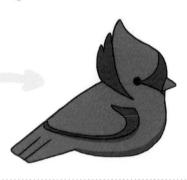

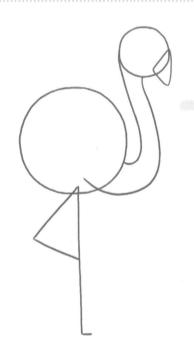

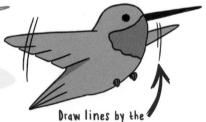

Draw lines by the wings to show that hummingbirds fly very fast.

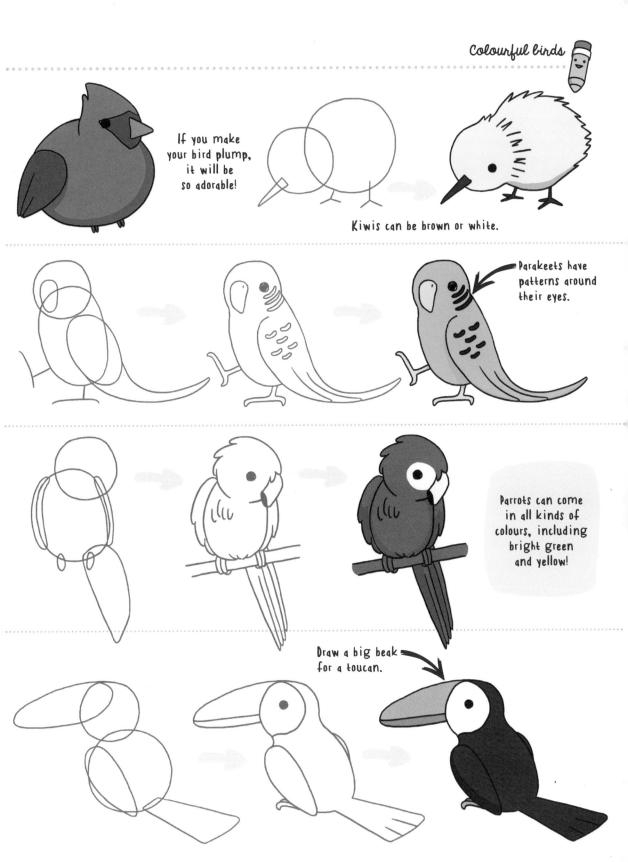

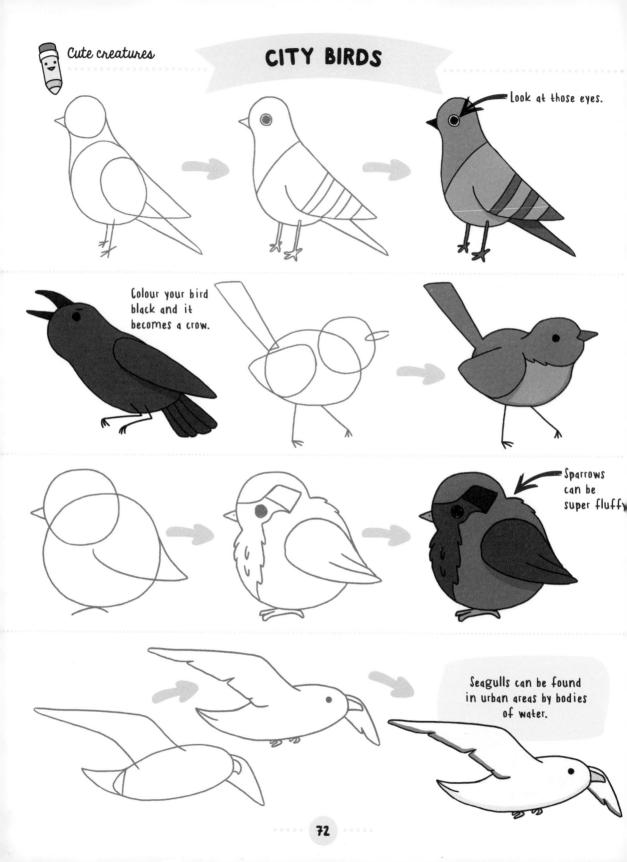

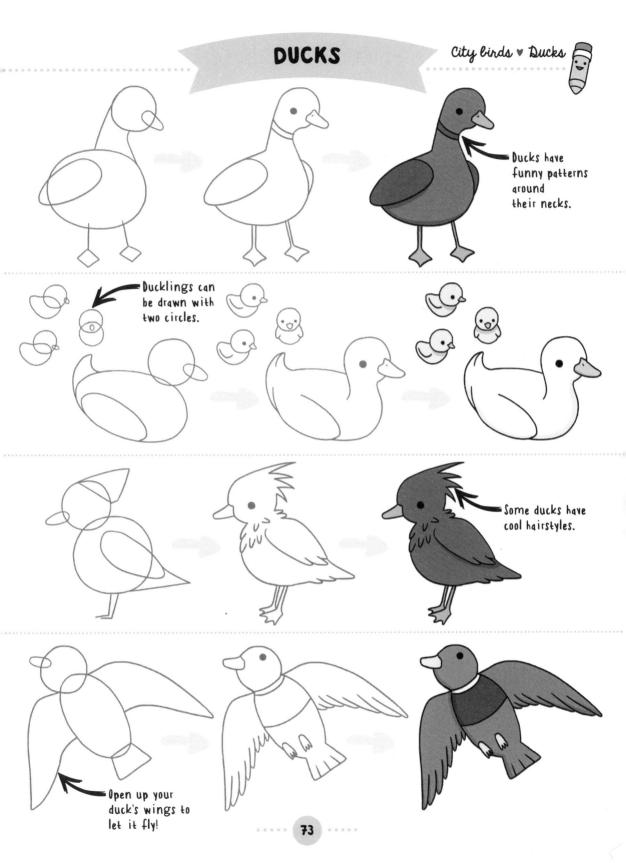

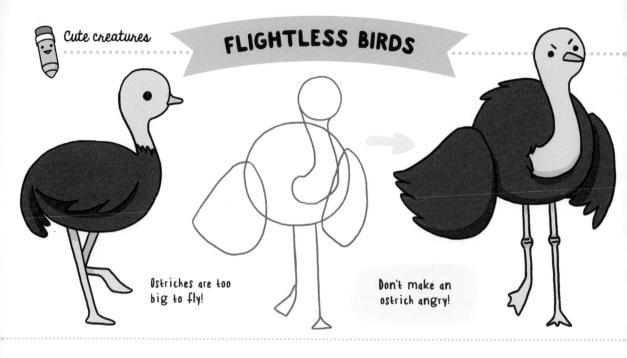

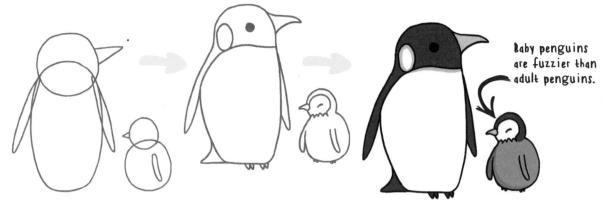

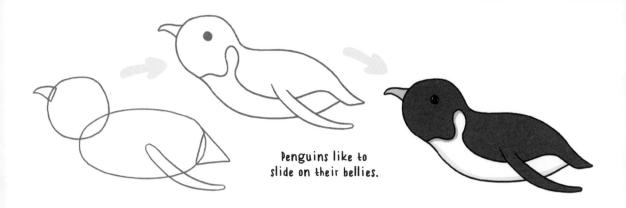

HUNTING BIRDS

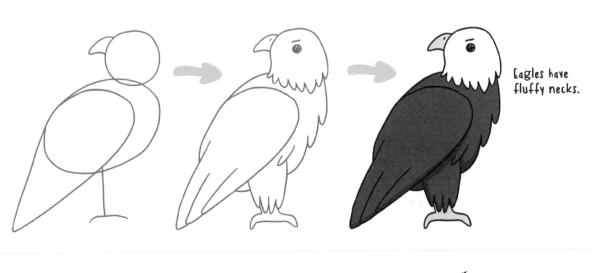

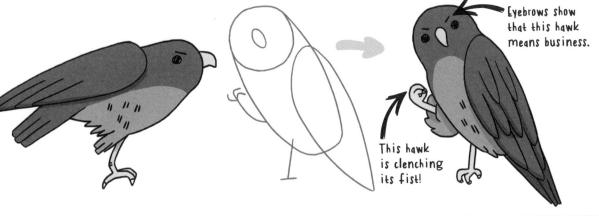

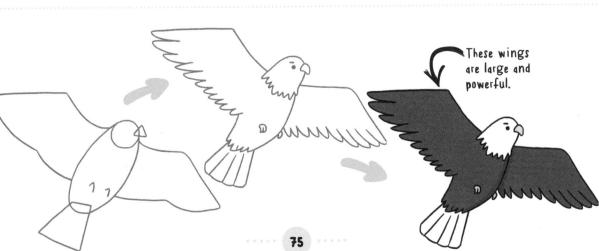

OWL

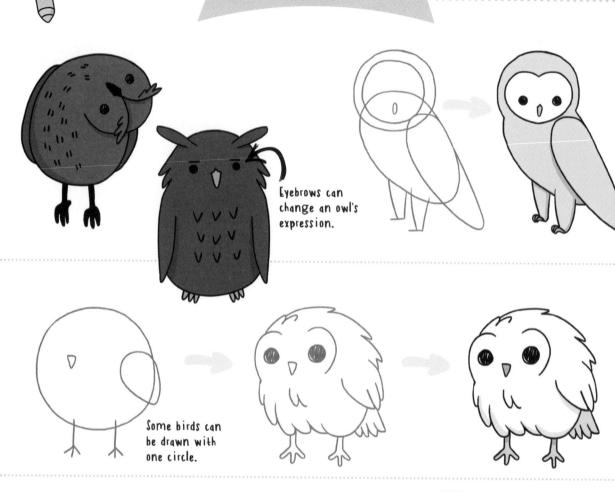

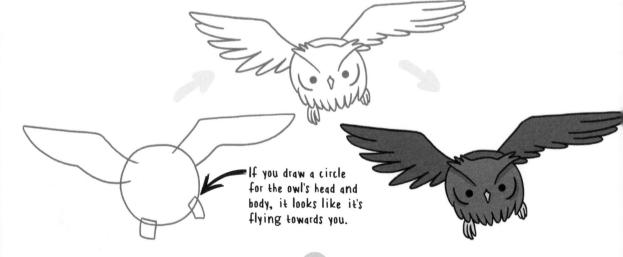

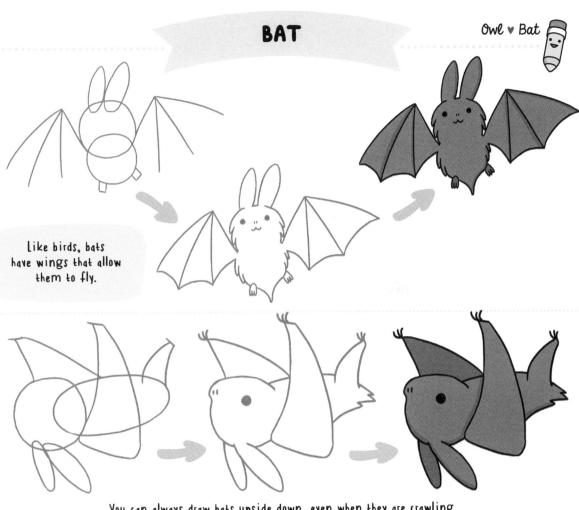

You can always draw bats upside down, even when they are crawling.

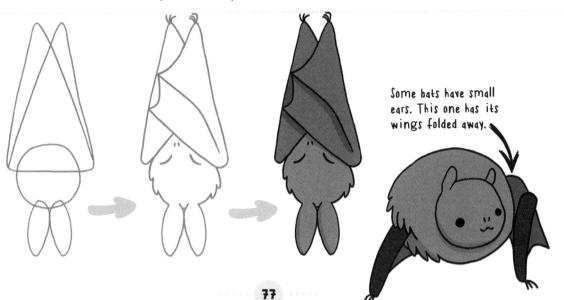

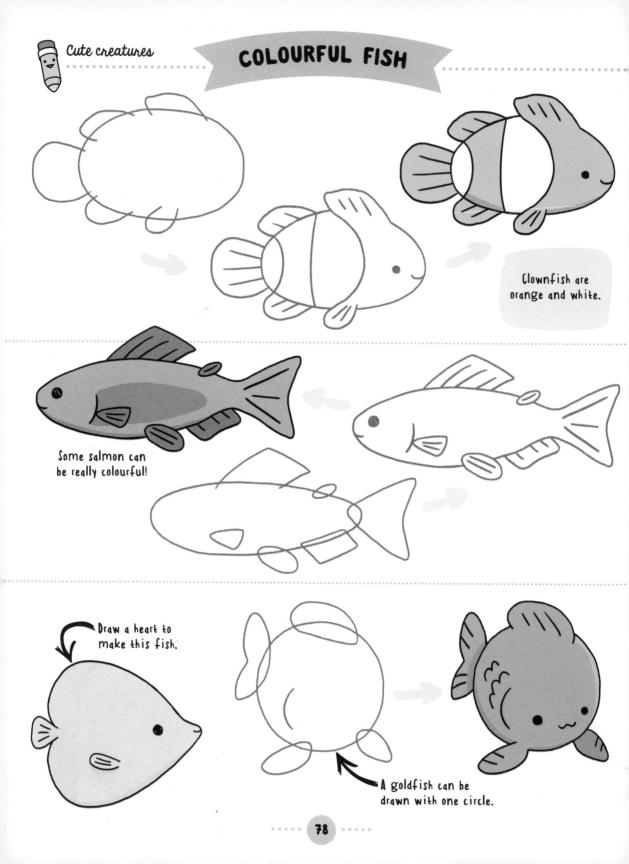

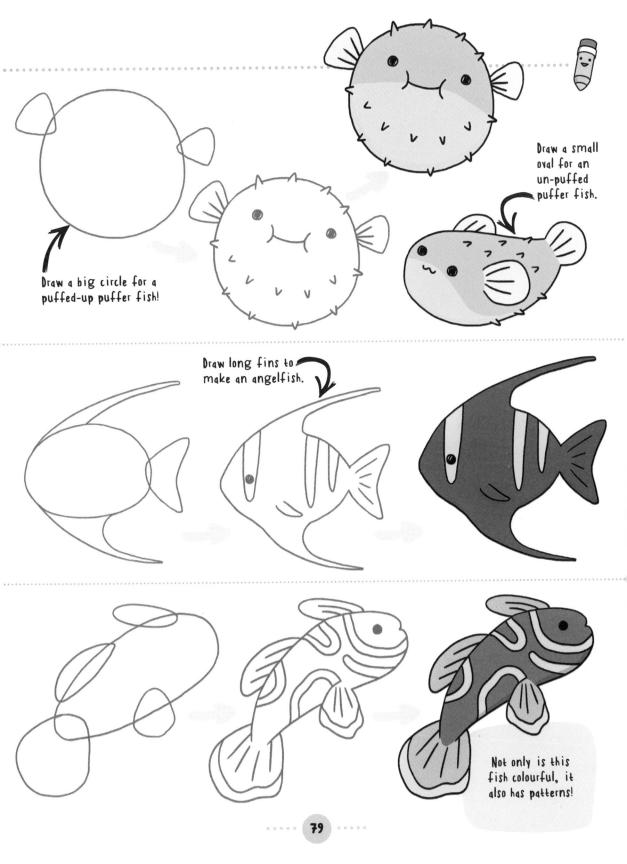

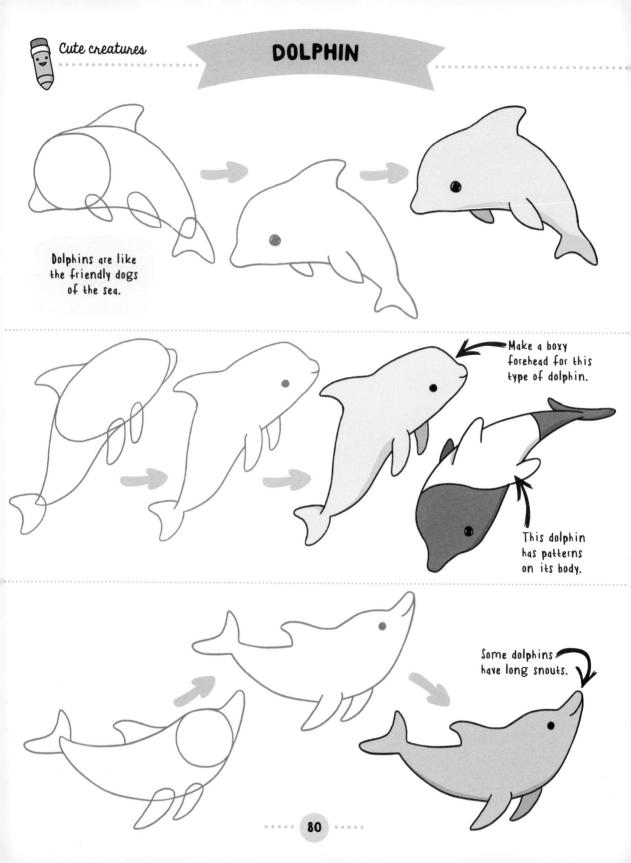

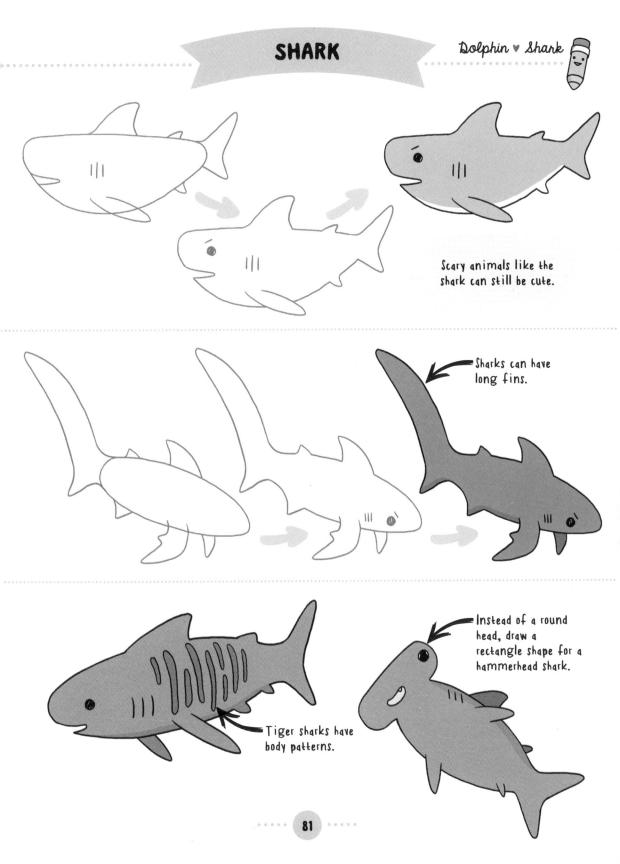

STINGRAY

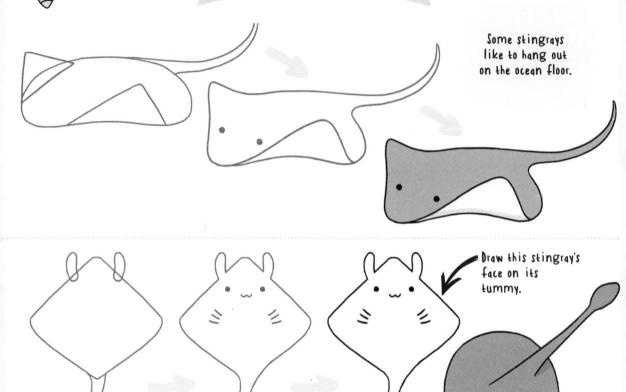

The back of a stingray can have patterns. Try creating your own!

Draw this stingray's face on its back.

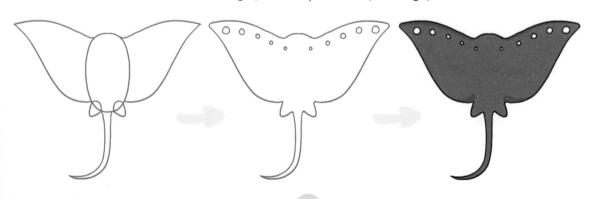

WHALE

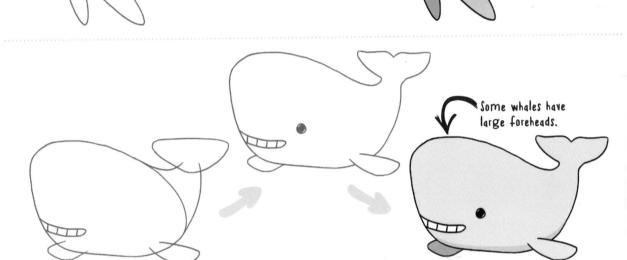

TENTACLES

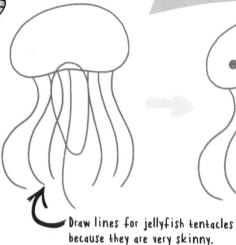

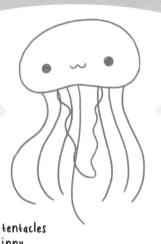

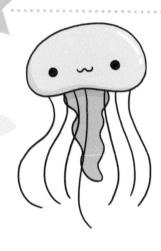

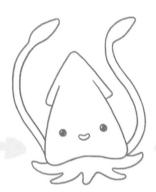

Draw the face on the shell or the body for different looks.

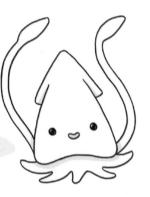

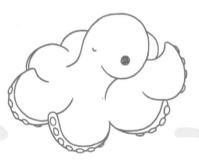

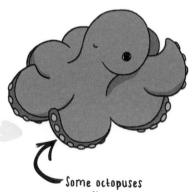

have flat arms.

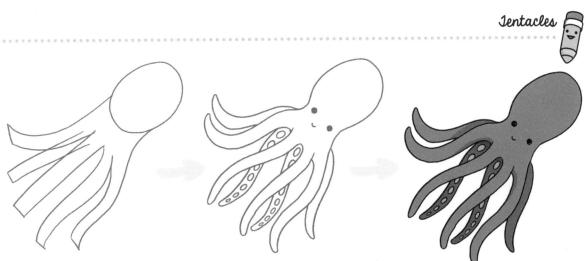

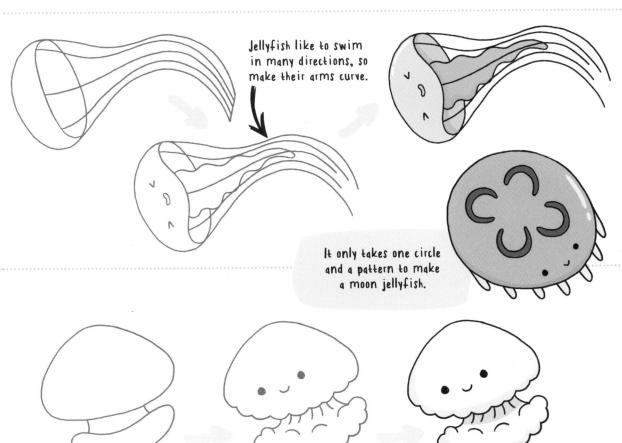

Some jellyfish are fluffier than others.

CATERPILLAR

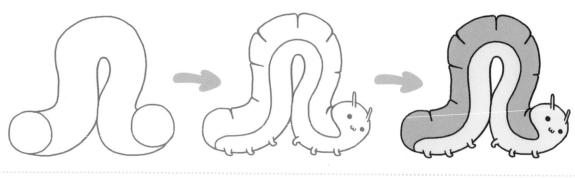

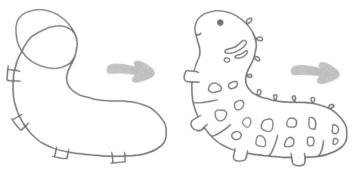

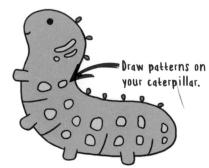

A caterpillar is a simple oval.

This caterpillar is so fuzzy!

BUTTERFLY & MOTH

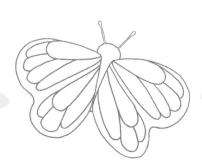

A butterfly can have many patterns on its back.

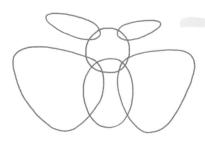

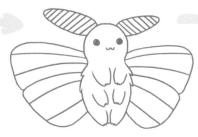

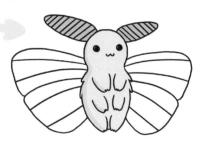

Moths are a little bulkier than butterflies.

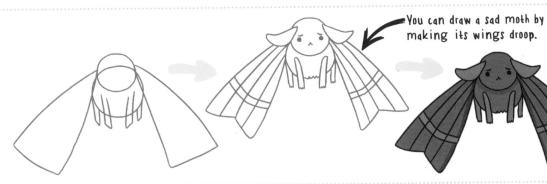

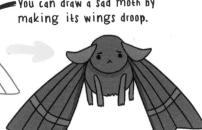

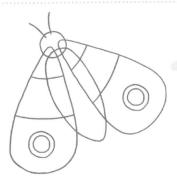

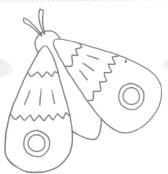

GRASSHOPPER

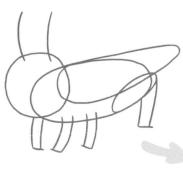

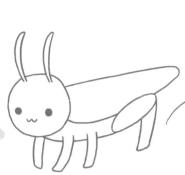

Grasshoppers can jump and fly.

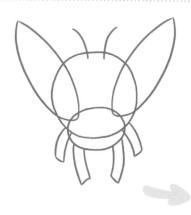

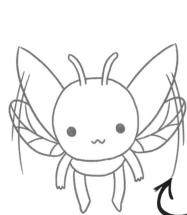

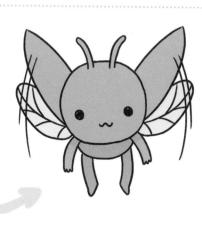

Draw lines by its wings to make it look like it's moving.

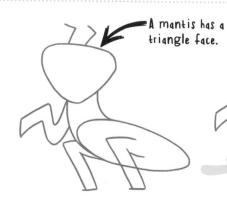

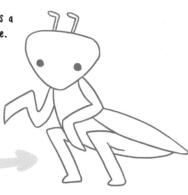

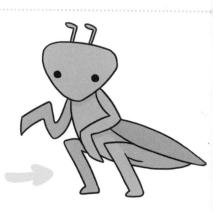

LADYBIRD

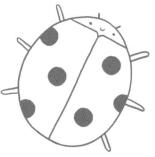

Different ladybirds have different patterns.

Try to come up with your own.

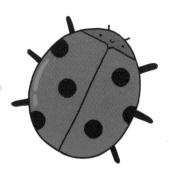

A flying ladybird!

This ladybird doesn't have spots on its back, but does on its face.

BEE

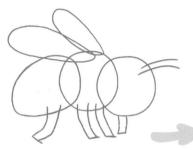

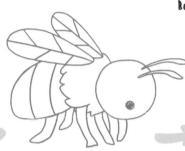

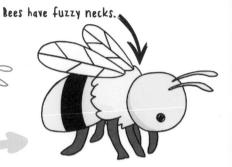

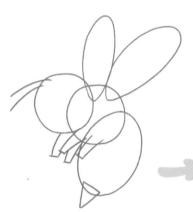

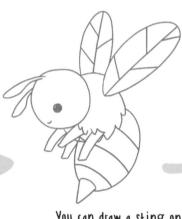

You can draw a sting on your bee to make it look fierce.

OTHER INSECTS

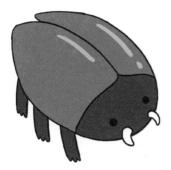

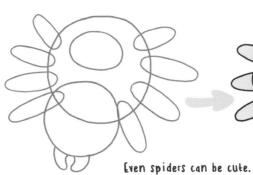

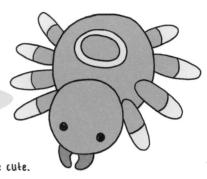

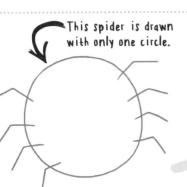

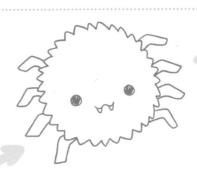

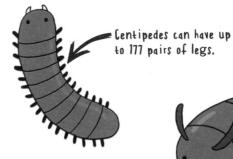

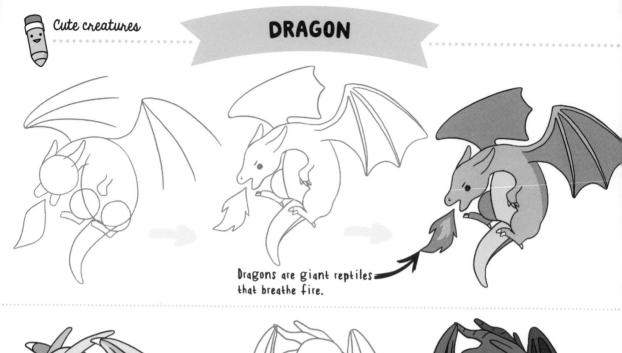

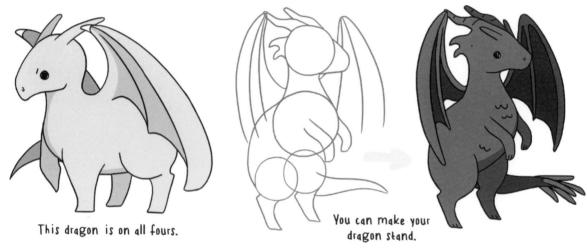

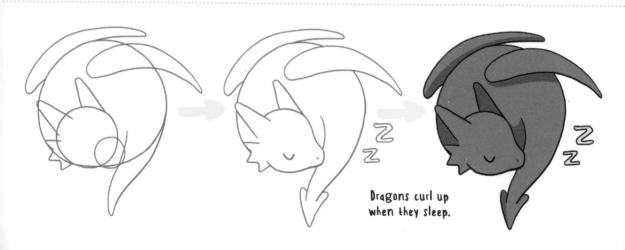

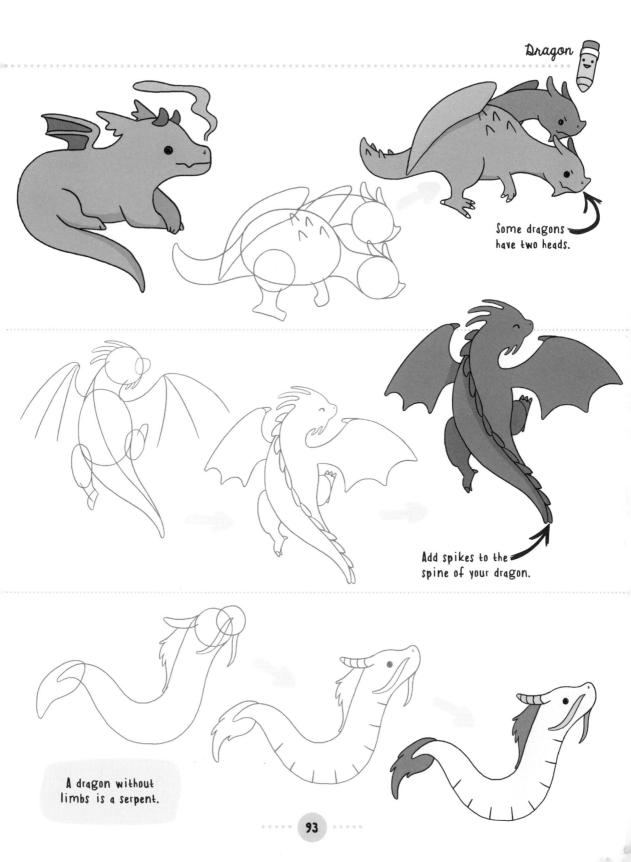

UNICORN & PEGASUS

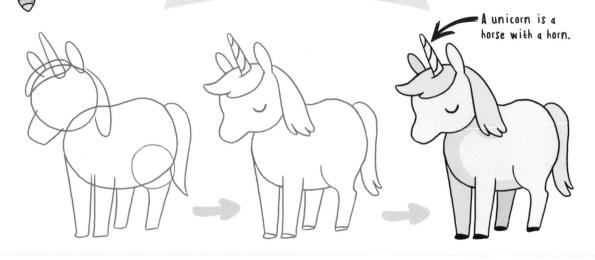

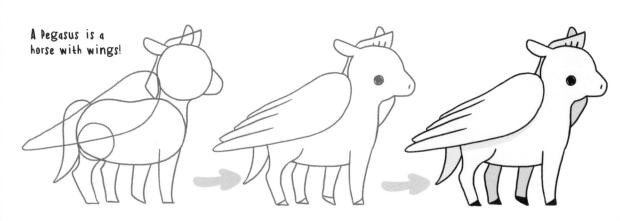

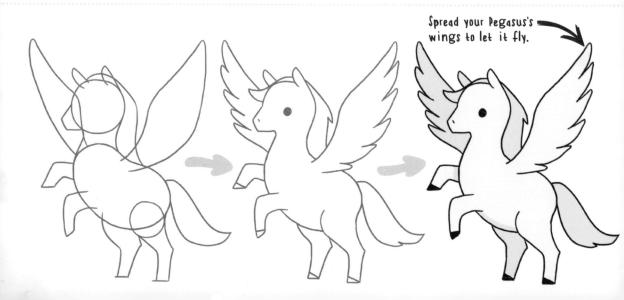

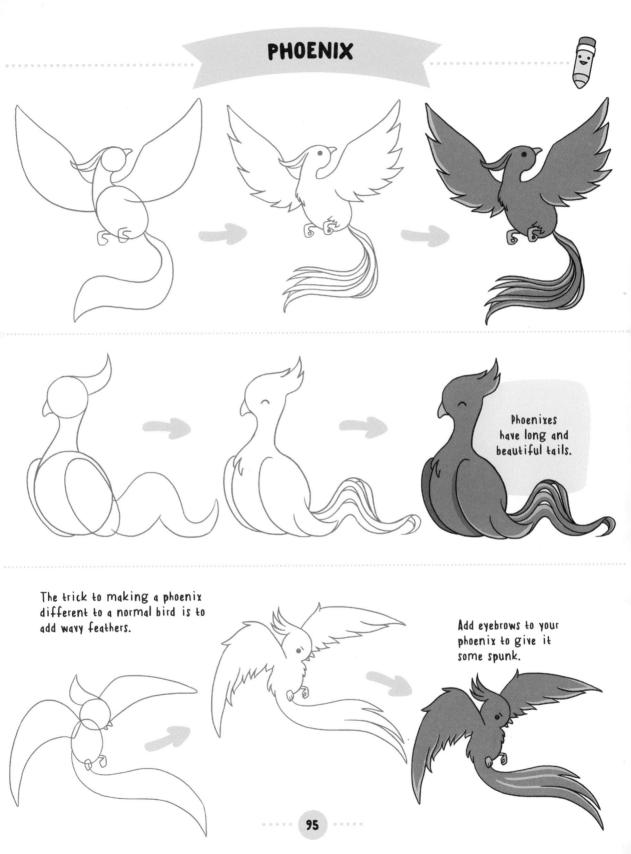

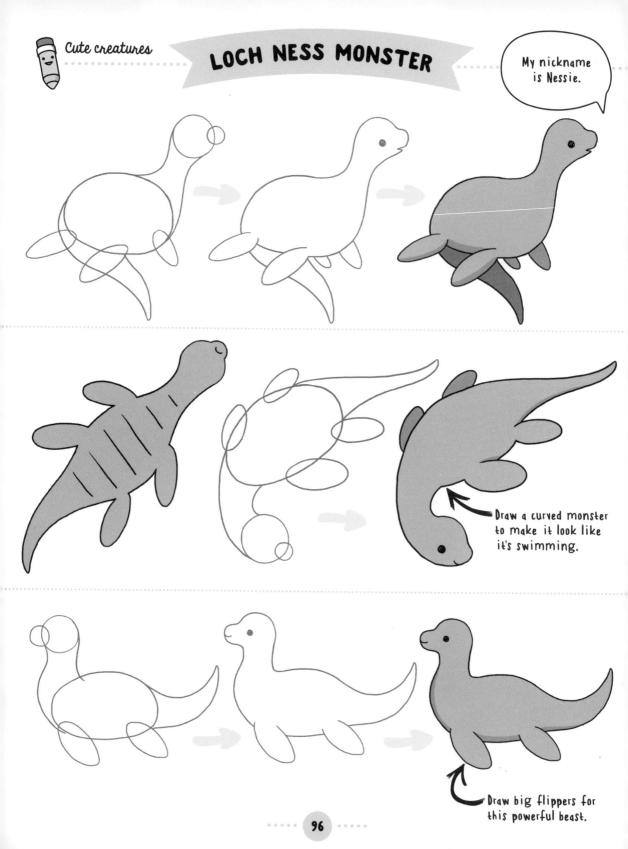

WEREWOLF

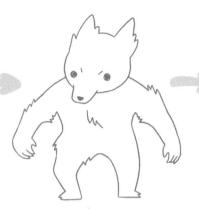

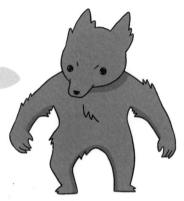

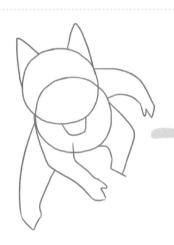

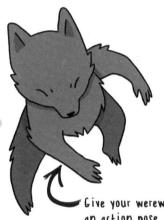

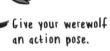

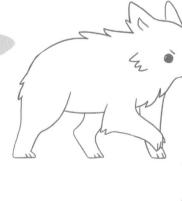

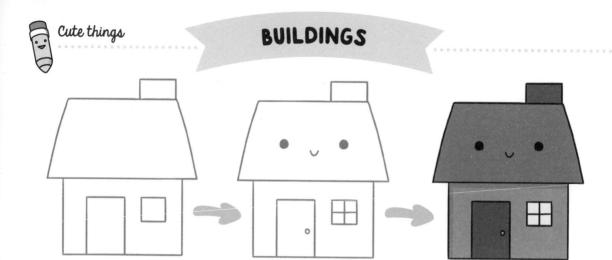

look how cute your home can be by just adding a face.

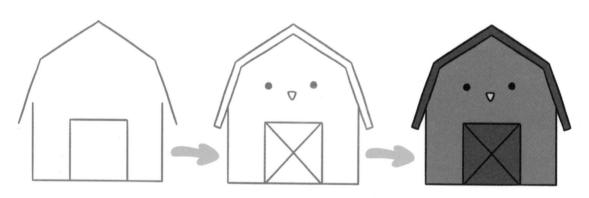

Draw a home for your farm animals.

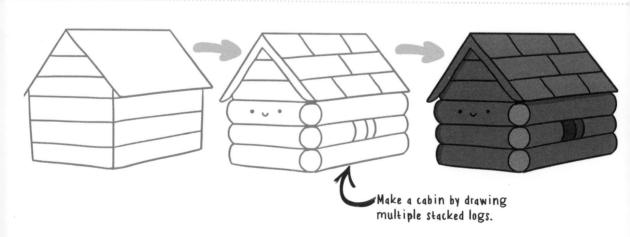

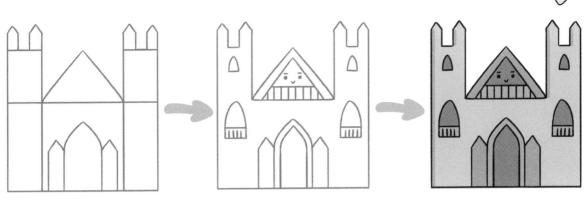

Cathedrals are large buildings.

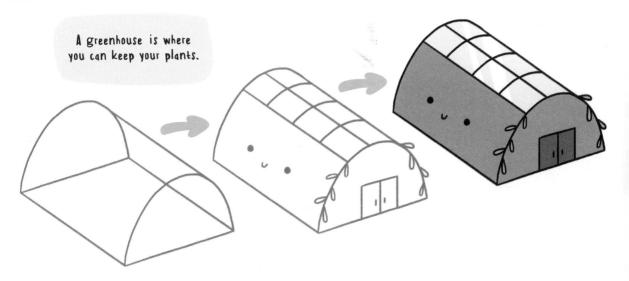

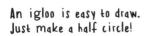

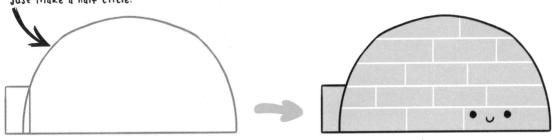

SKYSCRAPER

A skyscraper is a man very tall building. It can simply be drawn with a long rectangle.

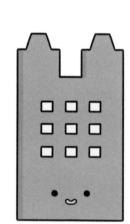

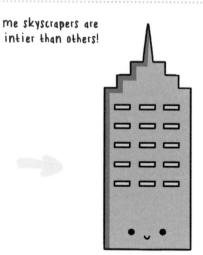

TENT

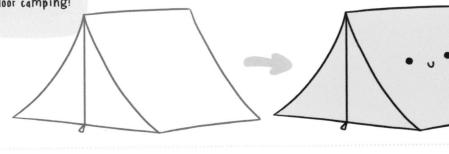

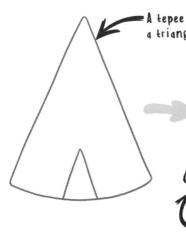

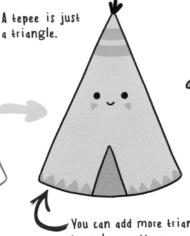

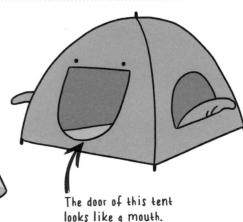

You can add more triangles to make a pattern.

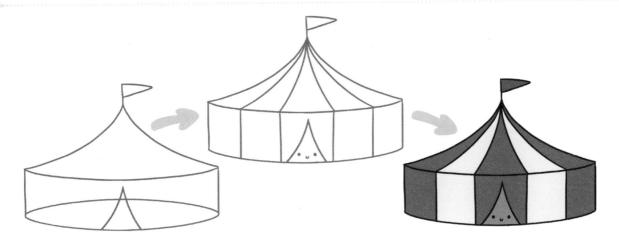

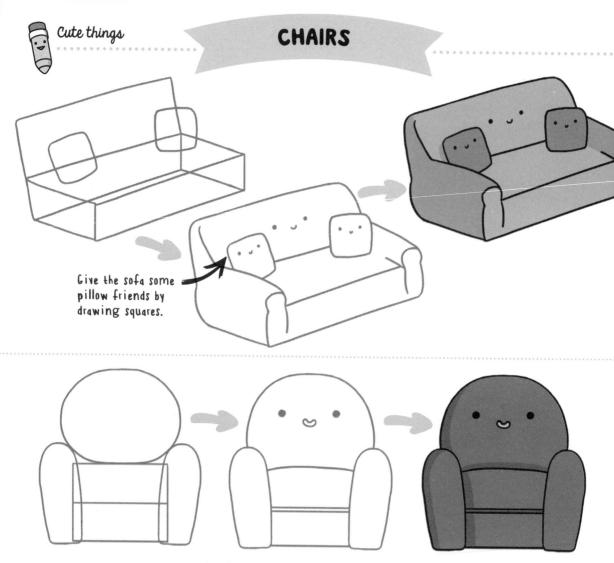

A sofa chair is like the sofa cut in half.

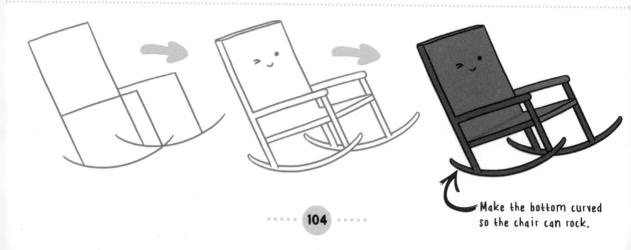

TABLES

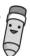

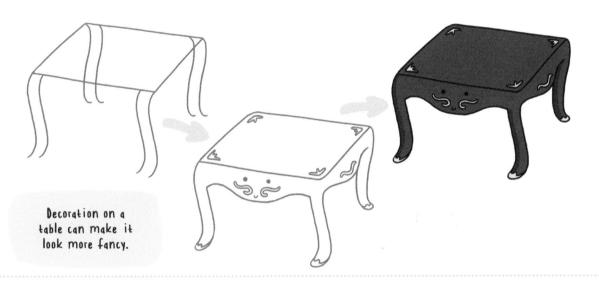

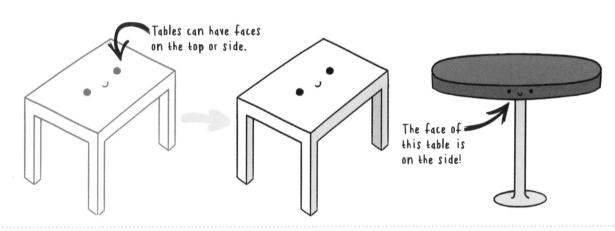

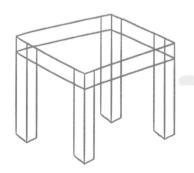

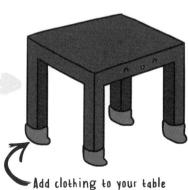

 Add clothing to your table to give it some personality.

COOKING TOOLS

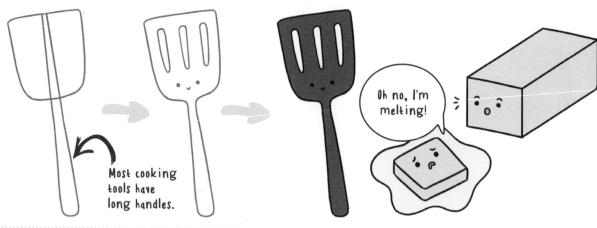

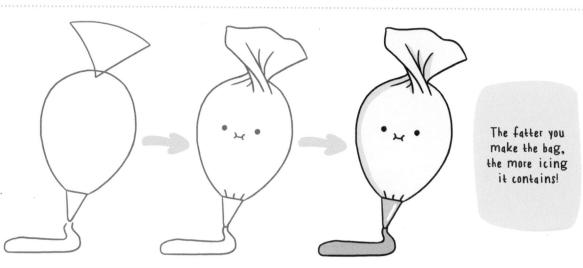

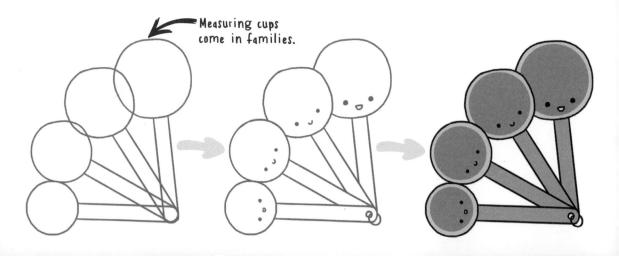

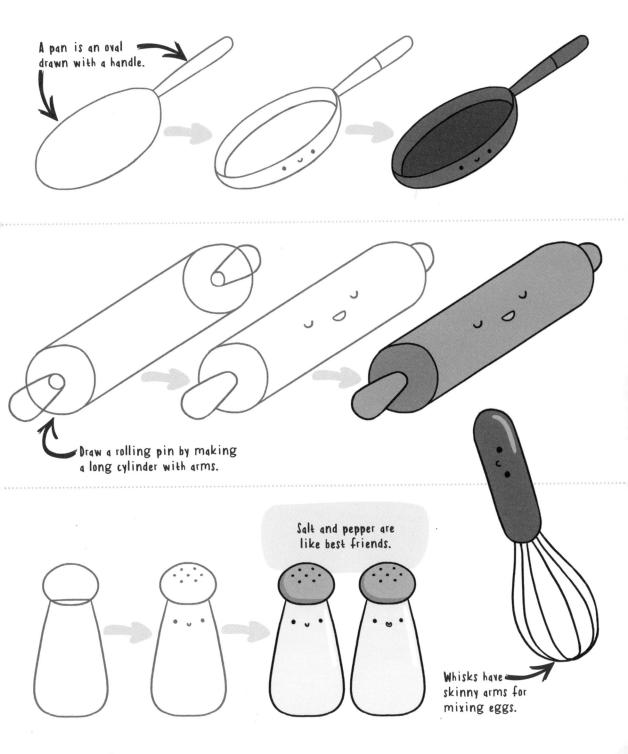

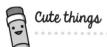

VEHICLES

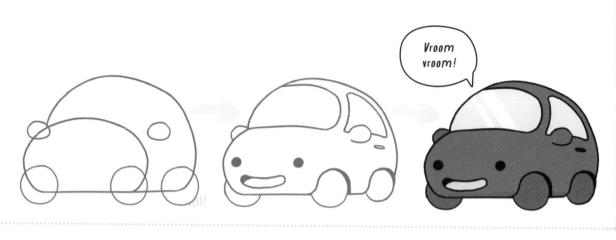

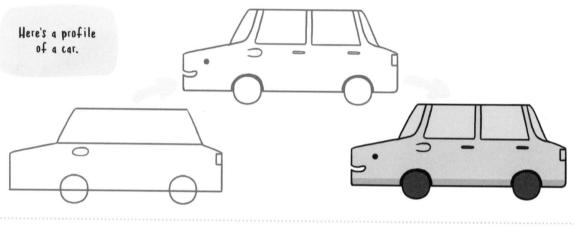

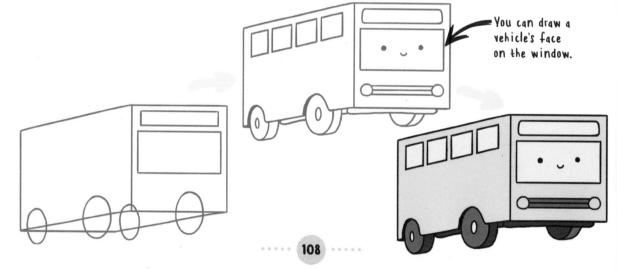

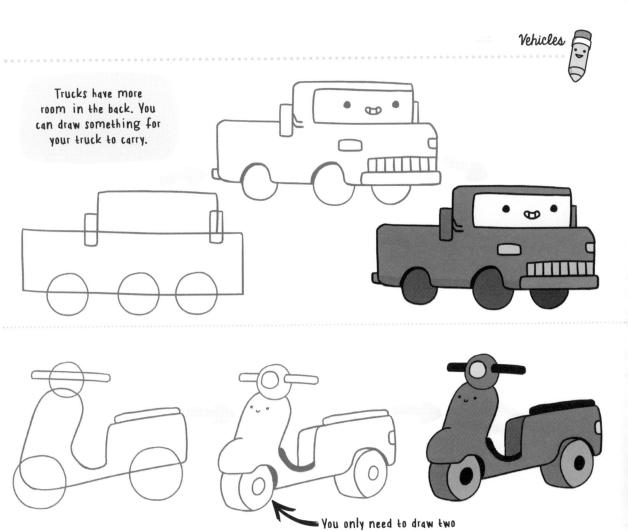

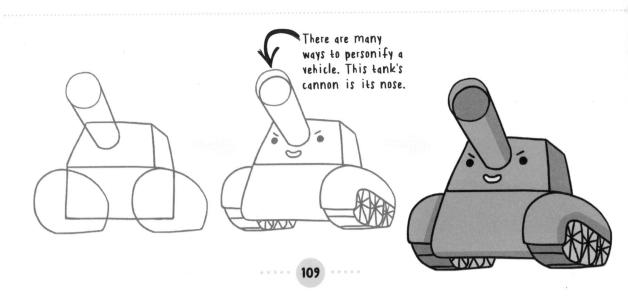

wheels to make a motorbike.

AIR VEHICLES

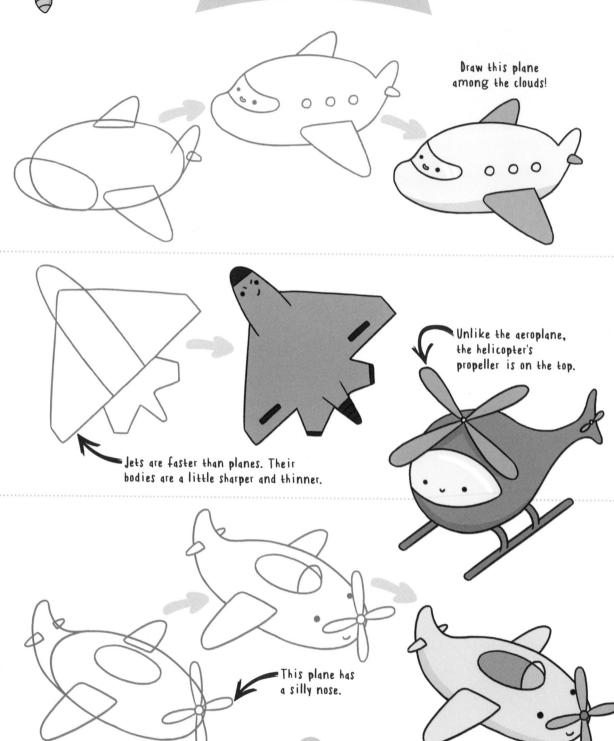

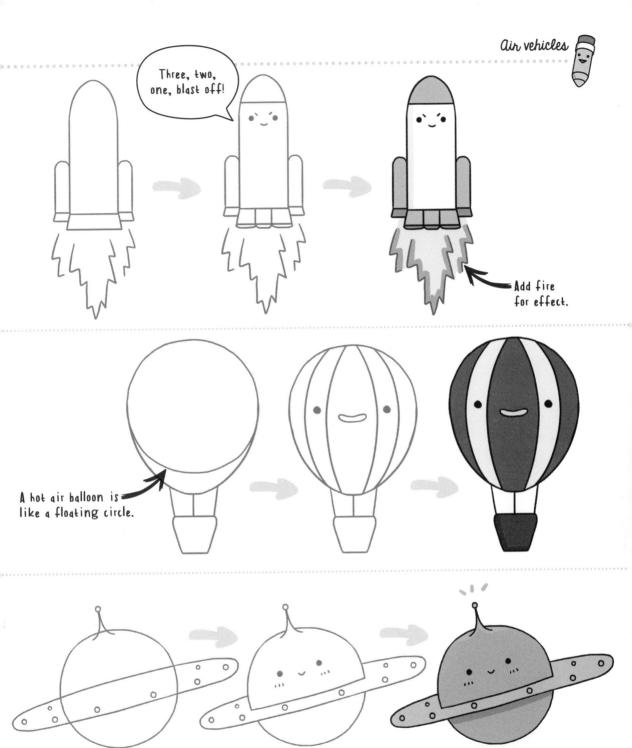

Draw a UFO in space or on Earth.

WATER VEHICLES

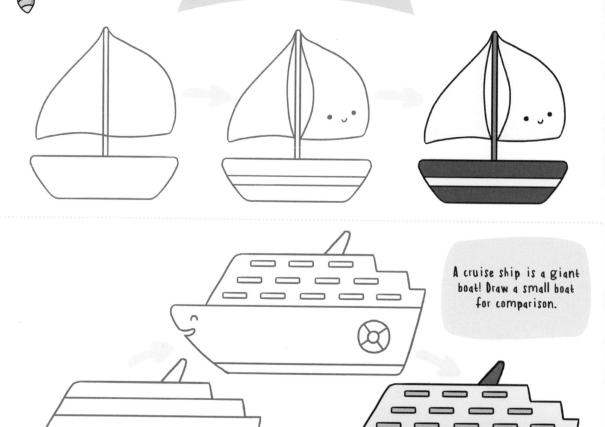

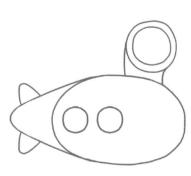

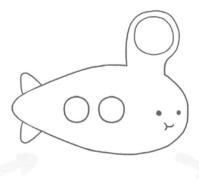

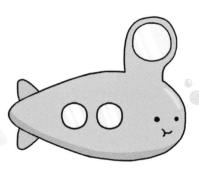

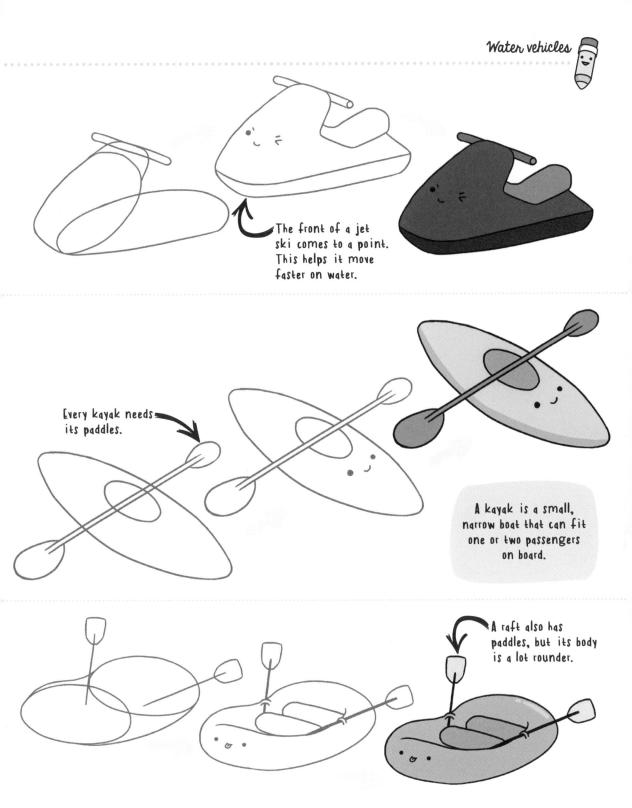

BOWL

Alphabet soup! Try spelling your name in this bowl.

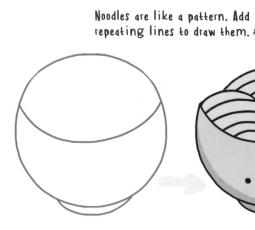

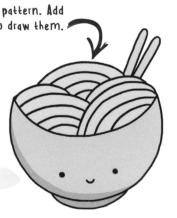

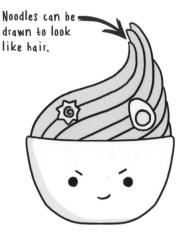

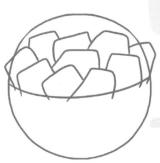

Make your salad even more colourful by adding nuts or fruit.

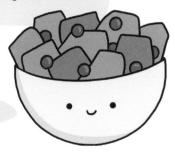

Instead of drawing a face on the bowl, try drawing it on the food.

BREAD

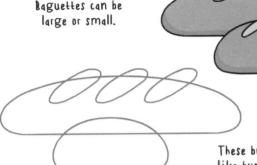

These bread buns are like bundles of circles.

Draw a puddle around the butter to make it melt on the toast.

Bread is usually bought in loaves like this.

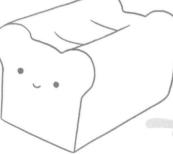

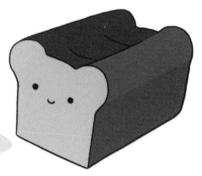

CANDYFLOSS

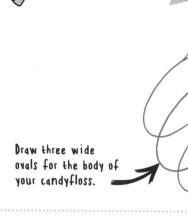

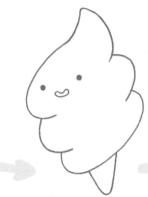

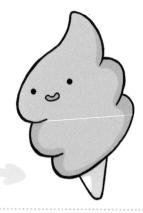

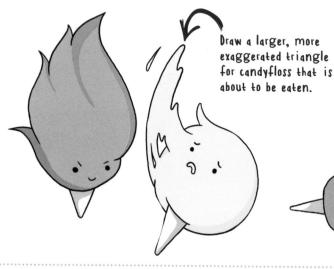

Candyfloss comes in all kinds of shapes.

Don't be afraid to make it tall!

Choose three cute colours for a bag of candyfloss.

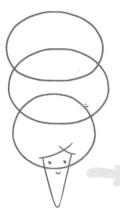

Drawing the face on the stick instead of the body makes the candyfloss look like hair!

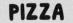

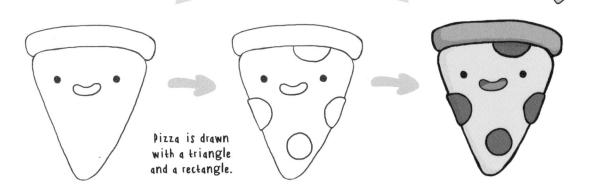

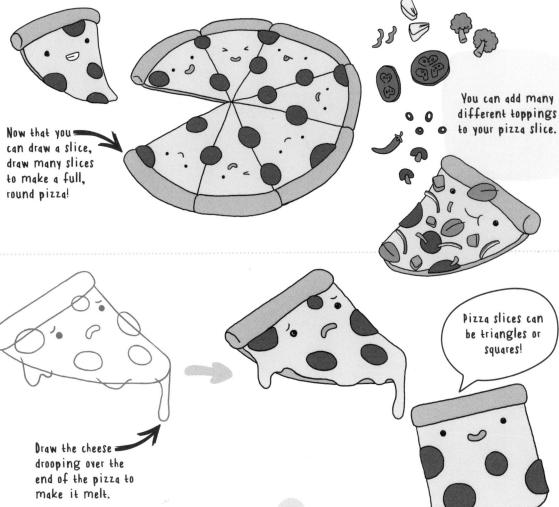

BURGER

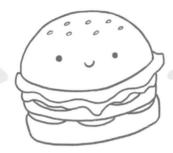

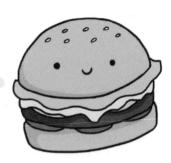

A hamburger has many colours and flavours!

Add a bite mark to the burger to make it look eaten.

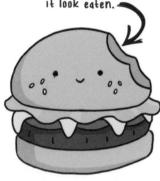

There are multiple layers to a burger. Draw what is usually in your burger.

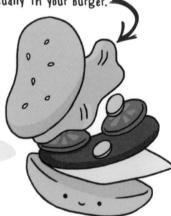

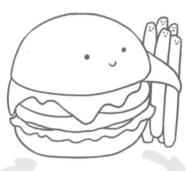

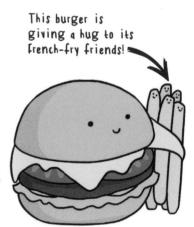

SWEETS

Draw many chocolate parts to make some chocolate buddies.

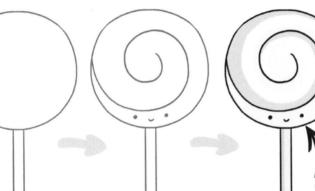

Wrapped sweets can be drawn with a circle and two triangles.

Candy corn is usually eaten during Hallowe'en, but I like to eat it all the time.

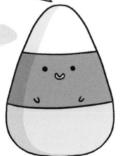

Add little white dots to show the sprinkled sugar on gumdrops.

DESSERT

If you'd like to, add more icing and fruit to the top or side.

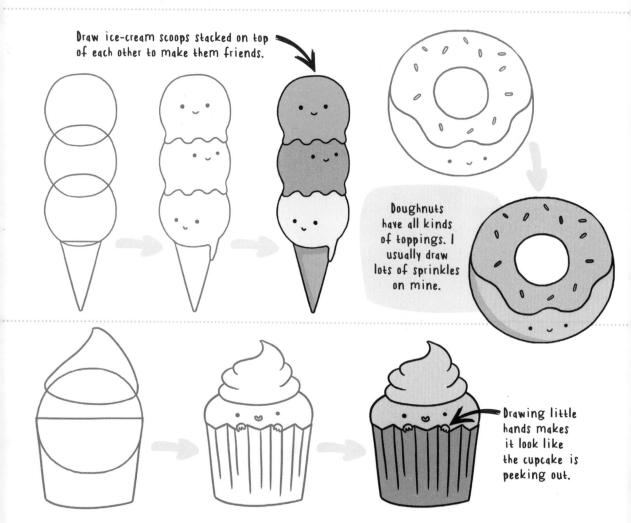

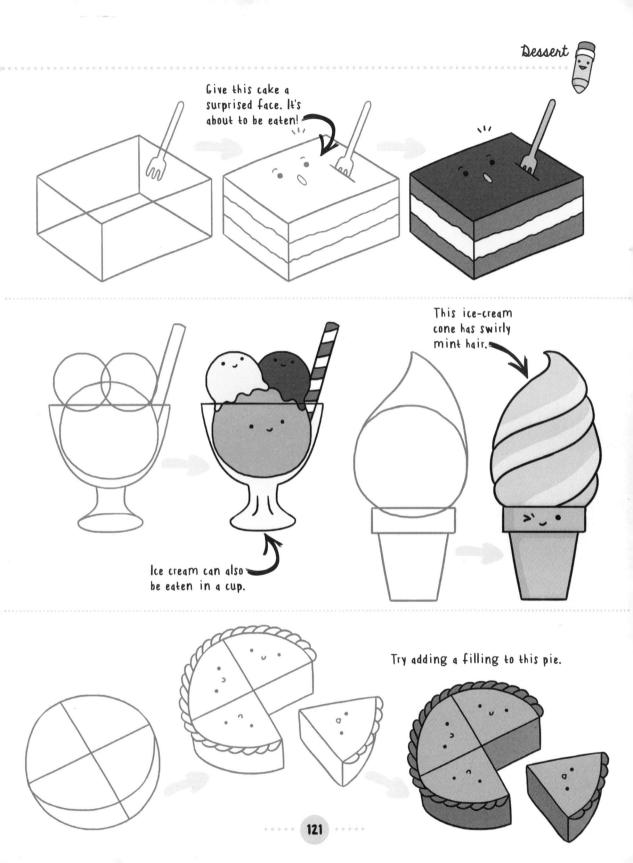

FRUIT

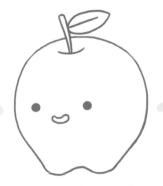

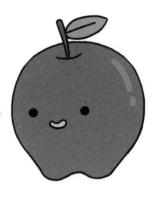

You can colour your apple red, yellow or green.

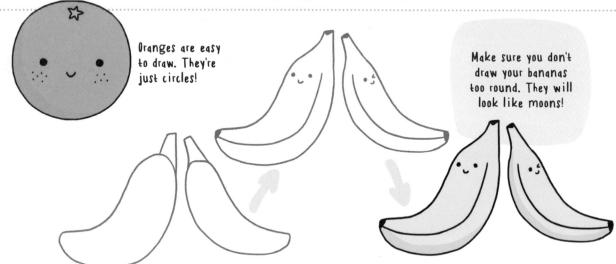

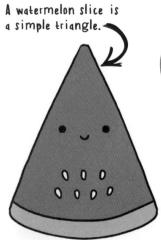

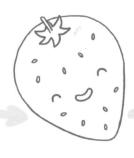

Look at the detail in this drawing. There are so many strawberry seeds!

SUSHI

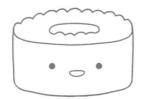

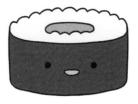

Sushi have a seaweed wrap and fish or rice filling.

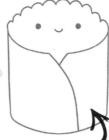

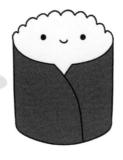

This sushi is wearing a hat.

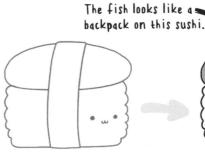

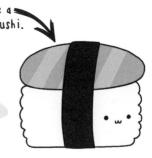

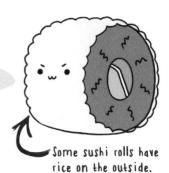

FLOWERS

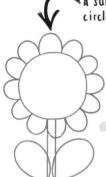

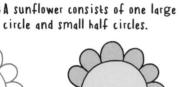

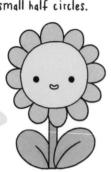

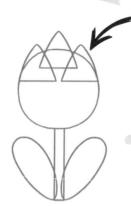

Tulips are made of a circle and triangles.

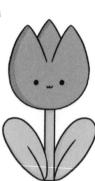

There are so many different types of flowers.

The lily has an interesting shape.

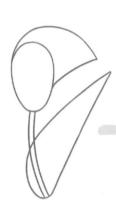

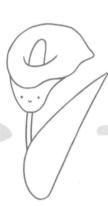

Draw many flowers wrapped together to create a bouquet! Choose different kinds of flowers and make your bouquet unique.

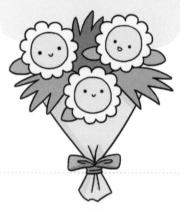

Roses are red, violets are blue, this rose can be drawn by you!

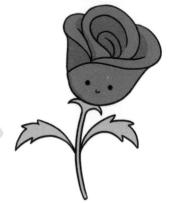

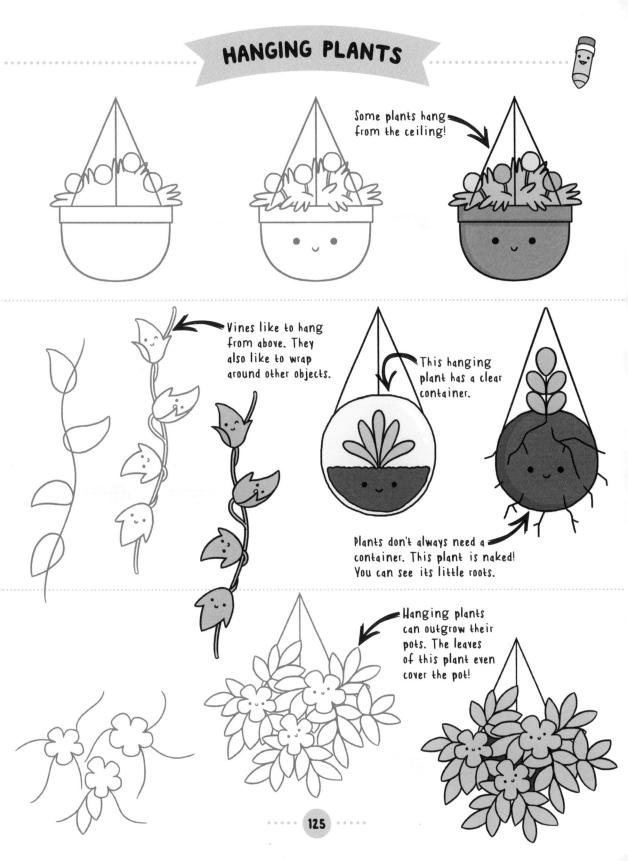

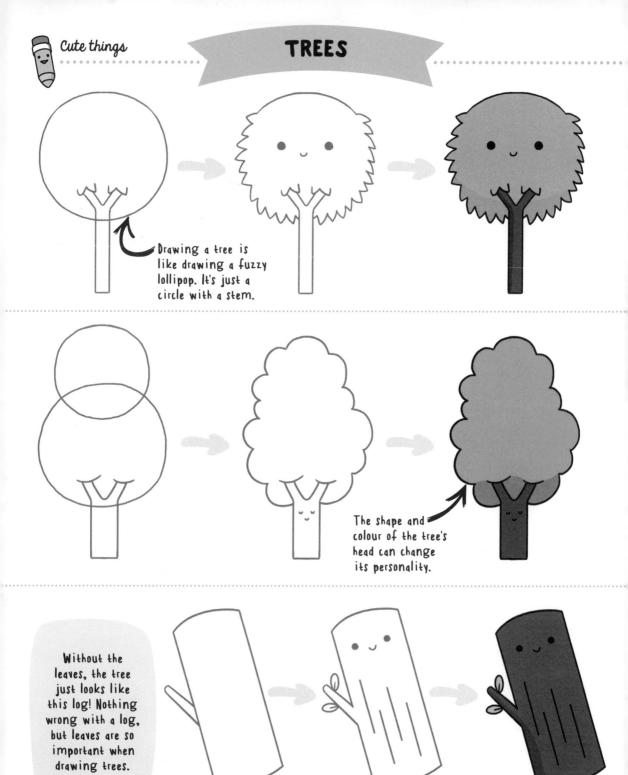

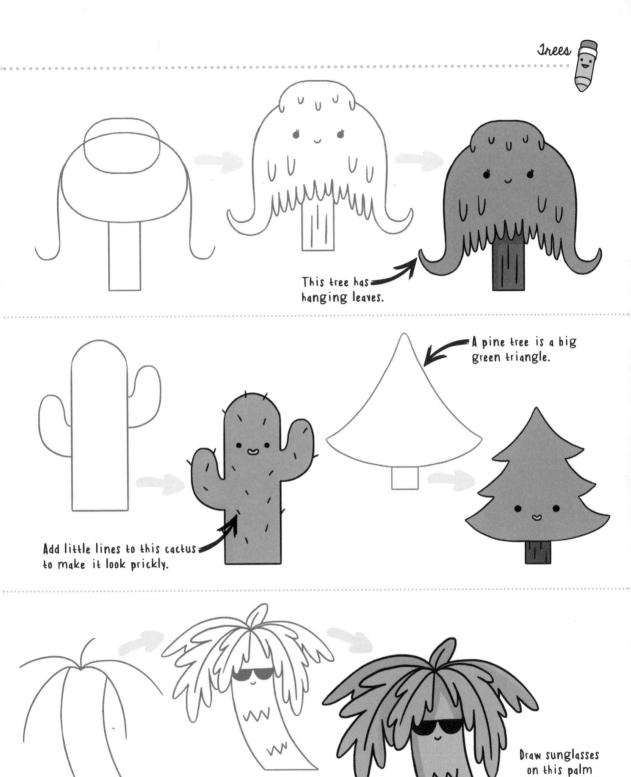

tree and it will instantly be ready for a nice holiday.

AUTHOR ACKNOWLEDGEMENTS

I want to thank my roommate, Jenny, for taking care of me during this cute adventure. Thanks for letting me use your room sometimes as a workspace, and reminding me to eat. And a big thanks to my little sister, Noodle, for helping me to choose illustration colours. I hope it was more fun than it was work!

CREDITS

Quarto would like to thank the following agencies for supplying images for inclusion in this book: Wilkins, Phil, p.10; Shutterstock/Africa Studio, p.11t; Shutterstock/PhuShutter, p.11m; Shutterstock/s_oleg website, p.11b.

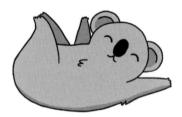